POSTCARD HISTORY SERIES

New York's
1939–1940 World's Fair

POSTCARD HISTORY SERIES

New York's 1939–1940 World's Fair

Andrew F. Wood

ARCADIA

Copyright © 2004 by Andrew F. Wood
ISBN 0-7385-3585-0

First published 2004

Published by Arcadia Publishing,
Charleston SC, Chicago IL, Portsmouth NH, San Francisco CA

Printed in Great Britain

Library of Congress Catalog Card Number: 2004101853

For all general information, contact Arcadia Publishing:
Telephone 843-853-2070
Fax 843-853-0044
E-mail sales@arcadiapublishing.com
For customer service and orders:
Toll-free 1-888-313-2665

Visit us on the Internet at www.arcadiapublishing.com

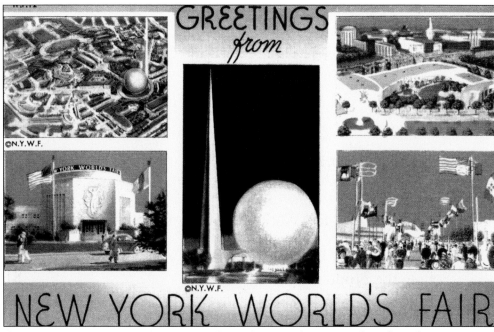

GREETINGS FROM NEW YORK WORLD'S FAIR. Countless postcards such as this one poured
forth from Flushing Meadows during the fair's 1939 and 1940 seasons. Promising an overview of
some of the many attractions waiting at the fair, this card depicts (counterclockwise from top left)
a bird's-eye view of Constitution Mall, an imposing image of the Administration Building, a night
scene of the Trylon and Perisphere theme center, a thronging crowd, and an overhead view of
the Medicine and Public Health Building. Deltiologists refer to this kind of postcard as a linen card
because of its high rag content and saturated dyes. Many postcard historians date the linen era as
1930 to 1945. (Image by Manhattan Post Card Publishing; licensed by New York World's Fair.)

CONTENTS

ACKNOWLEDGMENTS

Researching the 1939–1940 New York World's Fair can be an overwhelming task. Exhibit names and locations changed over the fair's two seasons, and the search for images demanded nationwide sleuthing. Thus, I am grateful to many people for their guidance—some I have met in person, some I have met virtually, and some I have merely admired from afar. In that latter category, I extend my gratitude to several intellectual giants upon whose shoulders I humbly stand, including Robert Rydell, Warren I. Susman, and David Gelernter. I must pause here to note that the latter's book, *1939: The Lost World of the Fair,* transformed my experience of the fair from an inanimate collection of guidebooks and postcards into a living, breathing entity. I also wish to thank the the following: the staffs at the Donald G. Larson Collection on International Expositions and Fairs, 1851–1940 (California State University, Fresno), at the Discovery Museum's Curt Teich Postcard Archives in Lake County, Illinois, and at the Queens Museum of Art in New York for providing essential insight along the way; the maintainers of the Web site www.archive.org and the Prelinger Archives, whose successful efforts to place corporate and amateur films of the fair in the public domain aided my research considerably; John Edward Powell's National Register of Historic Places application regarding Fresno's Tower Theatre, which offered essential insight into the design of the fair's Star Pylon; J. B. Zachman, curator of collections at the Greensboro Historical Museum, for his individual consultation; and Leonard Levitan, whose poster-sized aerial view of the fair offered visual orientation and artistic inspiration for this project.

Beyond those who provided essential background information, I also wish to thank the people without whom this book could not have been completed: the staff at Arcadia Publishing, particularly Jennifer A. Durgin and Tiffany A. Howe, for unfailing encouragement and patience; Brenda and Richard Musante of *Postcards, Books, Etc.* in Cotati, California, for sharing more than a dozen of their postcards and even more of their time; San José State University's Communication Studies Department, especially students in my rhetoric and public life courses, for fostering the kind of environment in which a passion for the fair could thrive; and Ohio University's Judith Yaross Lee, whose lessons in historiography guided me to completion of this book. Most of all, I wish to thank my wife and daughter for accompanying me on countless road trips, flipping through hundreds of postcard boxes, and indulging my obsession with this magical remnant of the past. Jenny and Vienna, I would love to time-travel to the fair, but I will always want to come home to you.

INTRODUCTION

Building the World of Tomorrow with the Tools of Today: this was the promise of the 1939–1940 World's Fair, held in Flushing Meadows, New York. We enter the fair with a 75¢ ticket in hand—it would be cheaper in 1940, but why wait? Towering ahead, the three-sided Trylon and its spherical neighbor, the Perisphere, stand triumphantly as a symbol of 1930s-era optimism. While some Depression-era writers dreamed of a Victorian age of confidence, David Gelernter, author of the sublime *1939: The Lost World of the Fair,* reminds us how the great fair epitomized an age of authority, marked by the geometrical simplicity—the sheer audacity—of the bold globe and obelisk.

We have come to the fair in search of more than just faded postcards and yellowed photographs. We engage in a peculiar archaeology of the present, revealing in fragments and memories the World of Tomorrow that became the reality of today. After all, 1939 promised us suburbs and interstate highways, television and global telecommunication. We had seen these visions before in bland utopias and fantastic cinematic fantasies. Yet never had the future become so vivid, so possible, so real. Of course, we also have come to find how that future was received by the public and how the 1940 season of the fair represented a revision of tomorrow in light of domestic doubts and international crises that raged in Europe and Asia.

In both its 1939 and 1940 incarnations, the fair made promises that stretched beyond the pedestrian visions of its predecessors. From the 1851 London Exposition with its Crystal Palace through the 1889 Paris Exposition with its Eiffel Tower and the 1893 Chicago Columbian Exposition with its White City, the great fairs of the past reflected a Victorian celebration of civilization, order, and national might. In contrast, the 1939–1940 New York World's Fair summoned the courage to define the world of tomorrow, imagining a gleaming metropolis of the year 2039 and calling it Democracity without so much as a smirk.

Stretching beyond the Trylon and Perisphere, the future spilled out in all directions. Behind the Grand Central Parkway, General Motors built the Futurama exhibit that inspired generations of Americans to follow their dreams on a vast network of superhighways (driving GM automobiles, of course). Beyond the Bridge of Wings, Westinghouse sold its vision of tomorrow with a "battle of the centuries" between Mrs. Drudge and Mrs. Modern—one washing her dishes, and the other using a brand-new Westinghouse dishwasher. Heading north to the AT&T Building, fairgoers queued to make free long-distance telephone calls. Meanwhile, visitors to the RCA Building (the one shaped like a giant radio tube) gazed upon the magic of television. Big and colorful and just a little bit cheesy, the 1939–1940 New York World's Fair delivered on its promises.

The fair gathered some of the most important designers of the 1930s to help build the world of tomorrow: bold thinkers like Norman Bel Geddes, Henry Dreyfuss, Raymond Loewy, and

Walter Dorwin Teague. From the imaginations of these visionaries, fairgoers encountered sleek and streamlined depictions of well-planned cities and consumer cornucopias. Of course, political powerhouses such as Fiorello La Guardia, Robert Moses, and Grover Whalen convinced kings, presidents, and captains of industry to pay for this international extravaganza. Together, they transformed a 1,216-acre junk heap in Queens into a dazzling assemblage of foreign, state, and corporate showcases.

In its two years, the fair drew an estimated 45 million visitors. They left with Perisphere pepper shakers, Heinz pickle pins, and tiny blue-white buttons that announced, "I have seen the future." More than six decades later, we are left with little more than memories, narratives, and artifacts. Happily, we have plenty of the latter, even as the first two grow a bit hazy. Postcards, photographs, pamphlets, brochures, advertisements, newspaper inserts, and other collectibles retain their ability to call us back to the fair. This book offers a humble collection of some of these images, focusing mainly on the postcard artifacts of both the 1939 and 1940 seasons.

The book is organized in four sections according to the fair zones outlined in the *Guide Book* to the 1939 season: Building the World of Tomorrow (theme center, Constitution Mall, and government), Moving Ideas in the World of Tomorrow (transportation, communications, and business), Selling the Products of Tomorrow (production, distribution, and community interests), and Entertainment and Eats in the World of Tomorrow (amusement and food). Although these zones were less formal in the 1940 fair, they offer a useful way to orient our tour. Along the way, we will encounter bits and pieces of a past that never quite left us. William Gibson calls them "semiotic ghosts," fragments of yesterday's tomorrows that haunt our memories and point the way to the future.

This book is your ticket. Hurry, the gates are closing soon.

One

BUILDING THE

WORLD OF TOMORROW

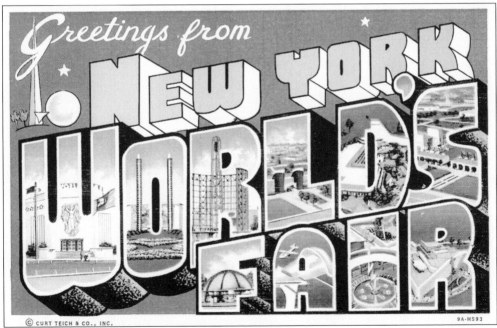

MORE GREETINGS FROM NEW YORK WORLD'S FAIR. This linen postcard offers an overview of the attractions found at the fair. Plenty of opportunities could be found on the 1,216 acres of land that once covered the Corona Dumps, also called the Valley of Ashes in F. Scott Fitzgerald's *The Great Gatsby*. On that swamp of trash and bog, a blur of city and amusement park glowed from 1939 through 1940. (Image courtesy Lake County, Illinois, Discovery Museum, Curt Teich Postcard Archives.)

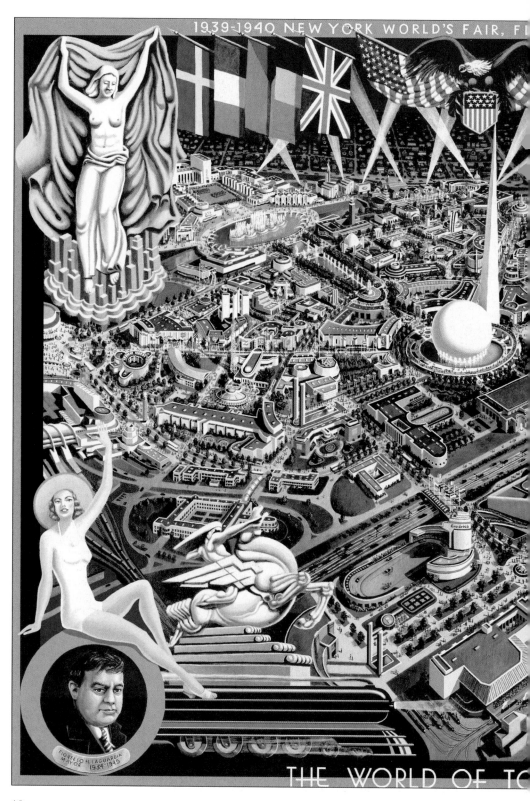

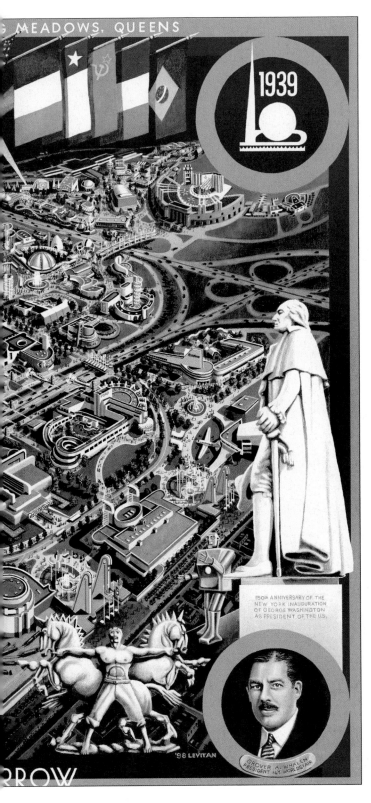

A GRAND VIEW OF TOMORROW. New York designer Leonard Levitan's 25.5-inch by 38.5-inch full-color bird's-eye rendering served as an essential resource in researching this book. When exact relationships of buildings were difficult to discern from the many maps produced for the fair, this meticulously researched print (available at http://www.levitandesign.com/) offered invaluable assistance. Downward from left to right are Albert Stewart's *Mithrana* sculpture; a bathing beauty from Billy Rose's Aquacade show; a portrait of New York Mayor Fiorello La Guardia; Joseph E. Renier's *Speed* sculpture; George H. Snowden's *Man Controlling Nature* sculpture; a portrait of fair president Grover Whalen; a tiny rendition of Electro, the Westinghouse Moto-Man; James Earle Fraser's *George Washington* sculpture; and the official logo for the 1939 New York World's Fair. (Reproduced with permission.)

11

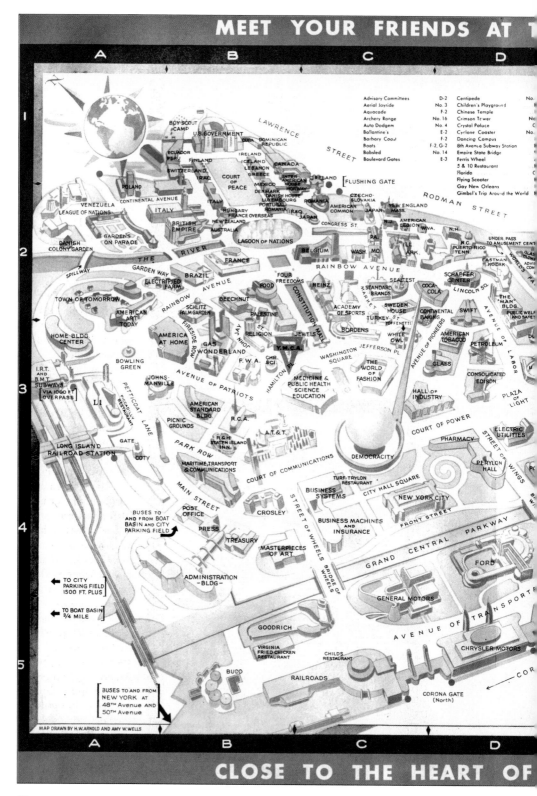

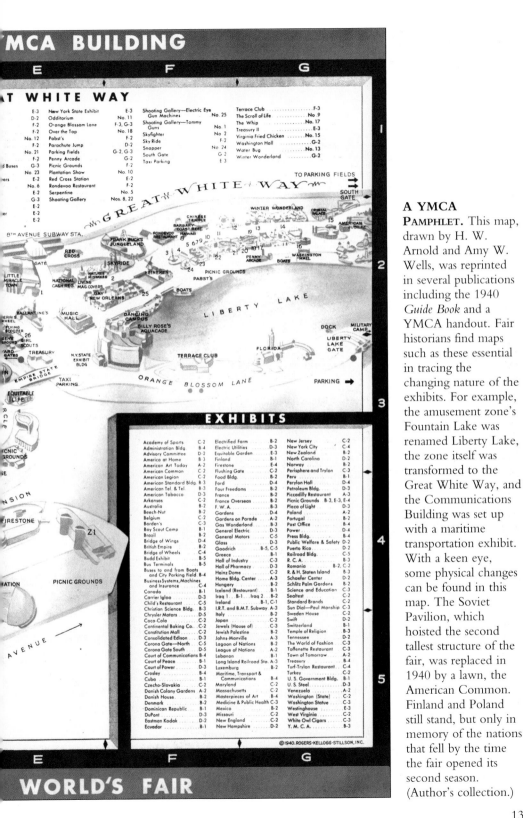

A YMCA PAMPHLET. This map, drawn by H. W. Arnold and Amy W. Wells, was reprinted in several publications including the 1940 *Guide Book* and a YMCA handout. Fair historians find maps such as these essential in tracing the changing nature of the exhibits. For example, the amusement zone's Fountain Lake was renamed Liberty Lake, the zone itself was transformed to the Great White Way, and the Communications Building was set up with a maritime transportation exhibit. With a keen eye, some physical changes can be found in this map. The Soviet Pavilion, which hoisted the second tallest structure of the fair, was replaced in 1940 by a lawn, the American Common. Finland and Poland still stand, but only in memory of the nations that fell by the time the fair opened its second season. (Author's collection.)

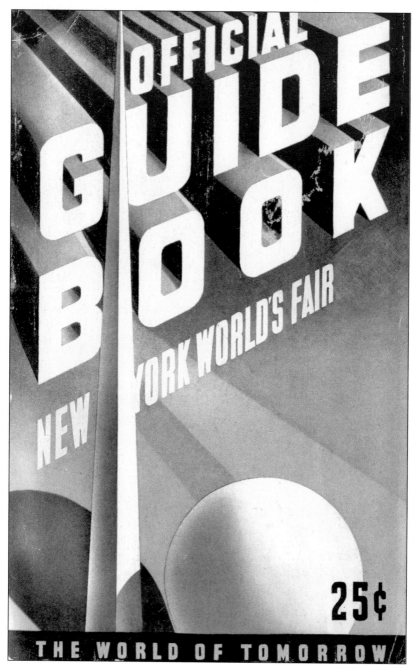

THE 1939 *GUIDE BOOK*. The *Guide Book* offered a combination of boosterism, hucksterism, and condescension in its attempts to train visitors in the most efficient ways to encounter the fair. Sprinkled with advertisements for sponsors of the fair's educational exhibits, the book reminds readers of the corporate foundations of the World of Tomorrow. The somewhat pedantic nature of its mission emerges in a guide on "How to Use Your Guide Book," which was "designed for you, written for you and placed in your hands to increase your enjoyment and appreciation of the New York World's Fair of 1939." Today, a reasonably maintained guidebook from the fair can be purchased for between $5 and $20. (Author's collection.)

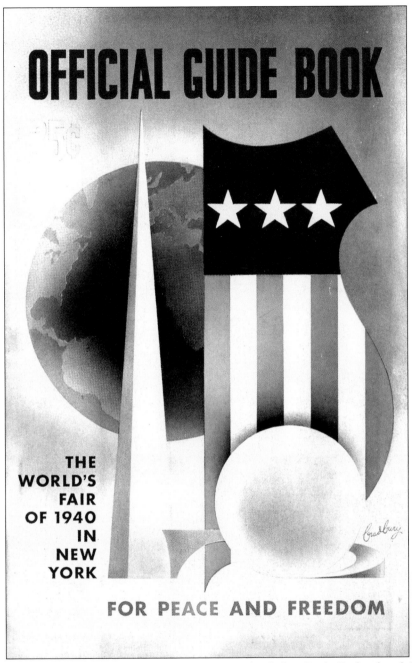

THE 1940 *GUIDE BOOK*. The second-season version of the *Guide Book* relaxed its prose significantly, filtering out some of the futuristic imagery and idealistic tone. Instead, the book celebrated the attractions as a giant state fair with creepy exhibits and generally wholesome entertainments. Barely a hint of the conflagration that had begun to engulf the world could be discerned by a reading of this book, even though its authors noted the eerie disappearance of some governmental buildings as the Nazi war machine marched across Europe. However, the increasingly jingoistic emphasis on the fair's American orientation suggests to the astute reader that the international world of tomorrow might have to wait a while. (Author's collection.)

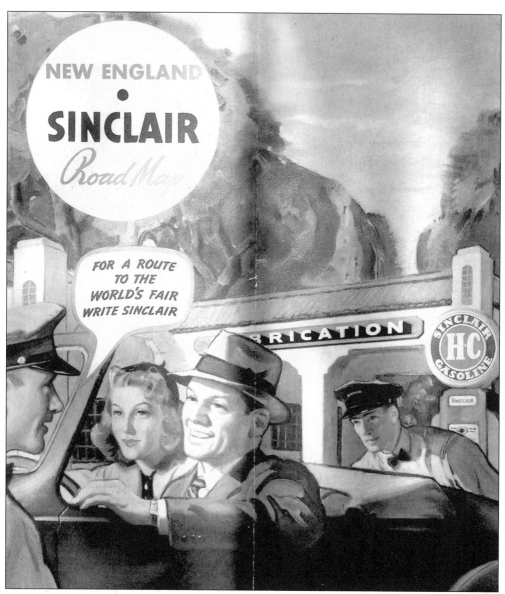

A SINCLAIR ROAD MAP. Although hard to believe in this day and age, gasoline stations once provided free maps to their customers. These graphic illustrations of America's pleasant motorways accumulated on dashboards, in glove compartments, and eventually in attics of homes around the world. This map announced that Sinclair was only too happy to help motorists find their ways to the world's fair. Sinclair was represented at the fair's petroleum exhibit, but it did not have a Dinosaur exhibit like the one that appeared in the Chicago Fair of 1933–1934. Fortunately, when the fair returned to New York in 1964, the dinosaurs reappeared. (Author's collection.)

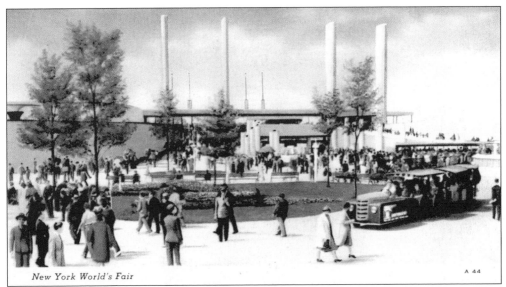

New York World's Fair

A 44

VISITORS ARRIVING. Guided by the grand ambitions of its planners, the 1939 New York World's Fair opened on April 30, inviting the world to Flushing Meadows. For 75¢, an adult could enter any of the 10 gates and tour the fair from 9:00 a.m. to 10:00 p.m. (the bawdy Amusement Zone stayed open until 2:00 a.m.). For 25¢, a fairgoer could buy the *Guide Book* before thronging into an artificial world of gardens, statues, and mammoth structures. By the time the fair closed on Halloween in its first season, an estimated 26 million people passed through the gates. (Created for Exposition Souvenir Corporation by Grinnell Litho Company; licensed by New York World's Fair.)

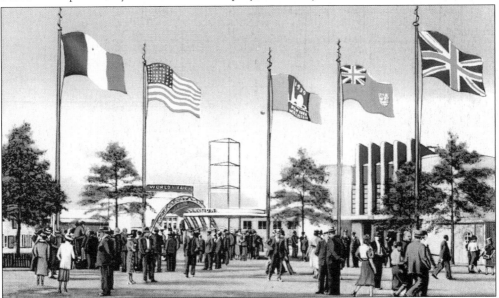

AN INFORMATION BOOTH. The fair offered 17 booths like this one near the Administration Building. Here, fairgoers could purchase the *Official Daily Program* with updated fair news for 5¢ or seek personal advice from a trained guide on which exhibits to visit. Information was also available by calling the booth at W O rld's Fair 6 - 1 9 3 9. (Image by Interborough News; licensed by New York World's Fair; courtesy Lake County, Illinois, Discovery Museum, Curt Teich Postcard Archives.)

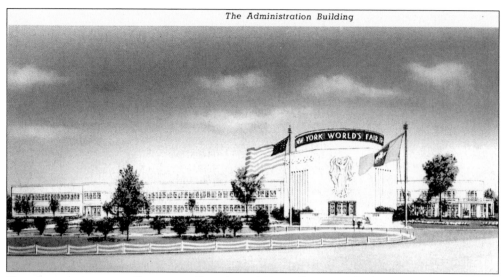

THE ADMINISTRATION BUILDING. Running a $155 million world's fair required an awesome degree of planning, particularly since the fair depended upon the labors of approximately 50,000 employees. The Administration Building, completed in 1937, was the nerve center of the whole operation. (Image by Frank E. Cooper; licensed by New York World's Fair; Courtesy Lake County, Illinois, Discovery Museum, Curt Teich Postcard Archives.)

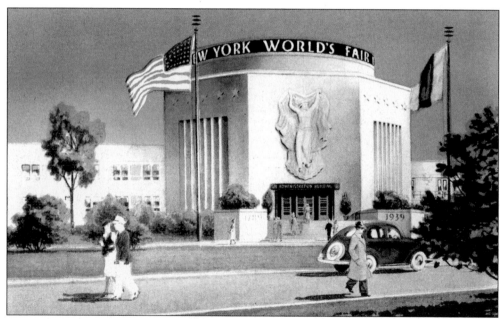

A CLOSEUP OF THE ADMINISTRATION BUILDING. This perspective offers a better look at Albert Stewart's relief sculpture *Mithrana* lifting the veil from the world of tomorrow. Inside, fair president Grover Whalen worked to lift that veil as much as Mithrana did. Gracing the cover of the May 1, 1939, edition of *Time* magazine, Whalen's grinning image recalls the "bully" attitude of Theodore Roosevelt. In the Administration Building, Whalen had a comfort enjoyed by both Roosevelts: an oval office. (Licensed by New York World's Fair.)

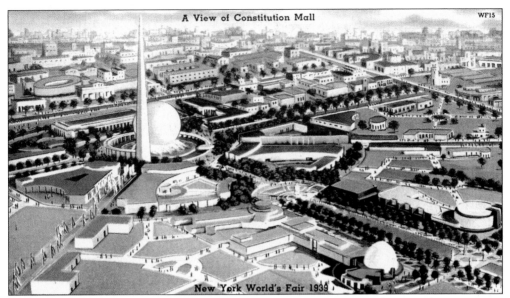

A View of Constitution Mall

New York World's Fair 1939

A VIEW OF CONSTITUTION MALL. This bird's-eye view of the fairgrounds presents an inaccurate picture of the 2,500-foot esplanade and its lagoons and statues. Beyond the hazy depictions of the General Motors and Ford Buildings, the postcard errs in its image of fountains that seem to hoist the 9-million-pound Perisphere skyward. Too much water splashing against the structure resulted in leakage. Thus, fair planners had to settle for less spectacular fountains. (Image published by Tichnor Brothers; licensed by New York World's Fair.)

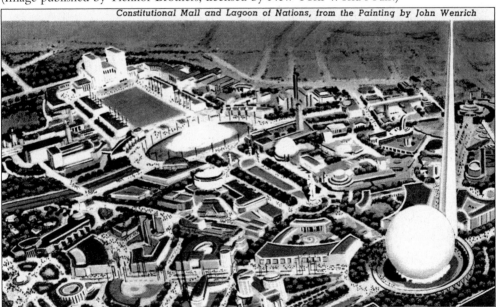

Constitutional Mall and Lagoon of Nations, from the Painting by John Wenrich

ANOTHER VIEW OF CONSTITUTION MALL. Try to imagine the scene that would have been offered in a similar aerial panorama in 1936, before the vast restoration project that transformed a dismal region of stagnant pools, odorous junk piles, and mountainous ash heaps into a world-class fairground. The 1939 *Guide Book* describes the fair's story as going "from dump to glory." (Painting by John Wenrich; image by Interborough News; courtesy Lake County, Illinois, Discovery Museum, Curt Teich Postcard Archives.)

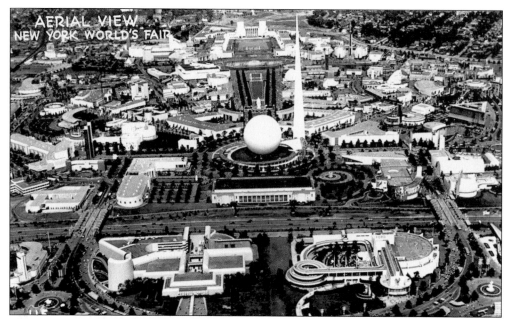

AN AERIAL VIEW OF CONSTITUTION MALL. The image on this real-photo postcard was taken from above the Chrysler Building looking over the Transportation Zone in 1940. It provides a historically accurate depiction of the fair's layout. (Licensed by New York World's Fair.)

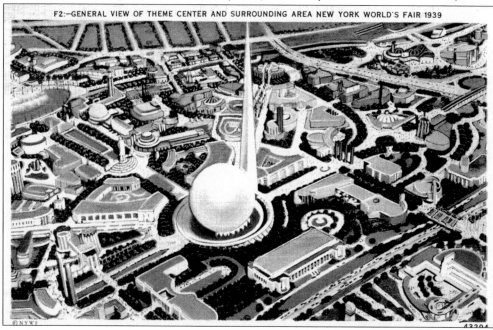

AN AERIAL VIEW OF THE THEME CENTER. This view looks toward the Trylon and Perisphere. Beyond these structures, the Avenue of Patriots leads to the Communications and Community Interests Zones, Constitution Mall leads to the Government Zone, and the Avenue of Pioneers leads to the Food and Production Zones. The building parallel to the Grand Central Parkway (mid-lower right), the New York City Building, remains today, a remnant of the fair. (Image by Manhattan Post Card Publishing; licensed by New York World's Fair.)

AN AERIAL VIEW OF THE TRYLON AND PERISPHERE. The Trylon and Perisphere marked the theme center of the fair. Examples of High Modern architecture, these structures were designed by Henry Dreyfus to evoke the finite and the infinite. Of course, local wags were just as prone to calling them the ball and the bat. Wallace K. Harrison & Andre Fouilhoux built them. (Created for Exposition Souvenir Corporation by Grinnell Litho Company; licensed by New York World's Fair.)

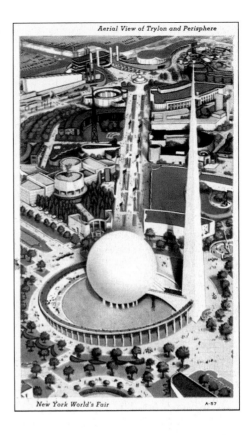

Aerial View of Trylon and Perisphere

New York World's Fair A-57

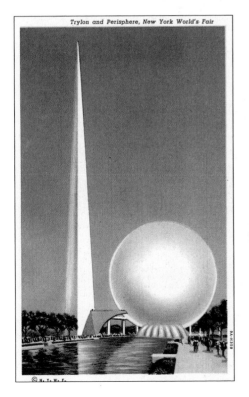

Trylon and Perisphere, New York World's Fair

A CLASSIC VIEW OF THE TRYLON AND PERISPHERE. The names "Trylon" and "Perisphere" were cobbled together from Greek roots to communicate the form and function of this centerpiece. *Tri* denotes the "three-sided" pylon, and *peri* refers to the "all around" view of tomorrow's world found within the huge globe. (Image by the Union News; licensed by New York World's Fair; courtesy Lake County, Illinois, Discovery Museum, Curt Teich Postcard Archives.)

21

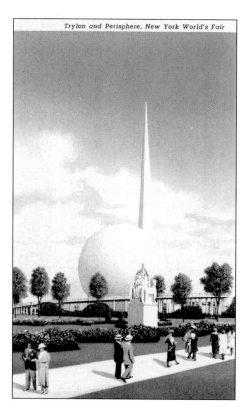

Trylon and Perisphere, New York World's Fair

THE TRYLON AND PERISPHERE WALKWAY.
Ranking with the Eiffel Tower among significant world's fair buildings, the Trylon and Perisphere appeared on literally thousands of artifacts celebrating the mammoth fair. (Image by Interborough News; licensed by New York World's Fair; courtesy Lake County, Illinois, Discovery Museum, Curt Teich Postcard Archives.)

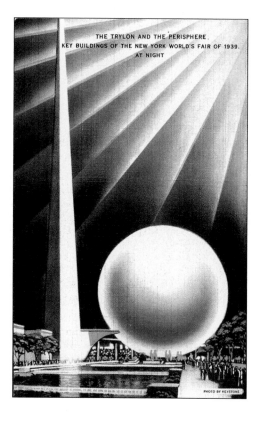

THE TRYLON AND THE PERISPHERE,
KEY BUILDINGS OF THE NEW YORK WORLD'S FAIR OF 1939,
AT NIGHT

PHOTO BY KEYSTONE

A NIGHT VIEW OF THE TRYLON AND PERISPHERE. With innovative lighting techniques, the Perisphere was lit at night in a manner to create the optical illusion of clouds and other fanciful patterns racing around its surface. On Halloween, it was transformed into a giant jack-o-lantern. (Image by Keystone for Tichnor Quality Views.)

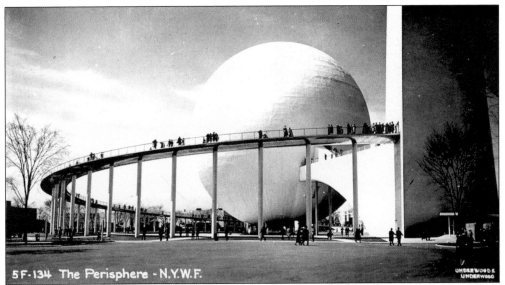

THE PERISPHERE AND HELICLINE. Visitors to the fair's theme center journeyed to the Democracity exhibit, located within the 18-story Perisphere, by riding an escalator from the Trylon. Inside the Perisphere—roughly twice the size of the interior of Radio City Music Hall—fairgoers stood on moving platforms and gazed over a diorama of suburban life. Afterward, they exited the exhibit, using the Helicline, a 950-foot ramp that circled the Perisphere. (Real-photo postcard; image by Underwood & Underwood.)

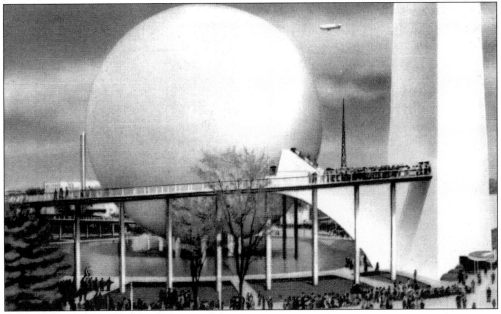

THE PERISPHERE AND HELICLINE, ANOTHER VIEW. The Trylon and Perisphere were advertised as being 700 feet tall and 200 feet in diameter. However, as was common during the construction of the fair, neither structure was built entirely to plan. The Trylon stood 610 feet high, and the Perisphere was 180 feet in diameter. Both were demolished at the conclusion of the fair. (Created for Exposition Souvenir Corporation by Grinnell Litho Company; licensed by New York World's Fair.)

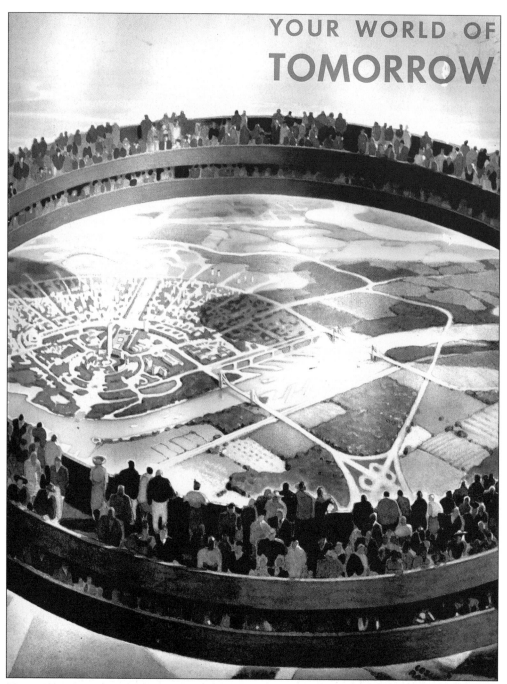

YOUR WORLD OF TOMORROW. Based largely on Ebenezer Howard's Garden City concept, the Perisphere's Democracity exhibit oriented the future of public life around types of suburbs that are commonplace today. Centerton was the cultural, educational, and corporate center, ringed by Pleasantville and other bedroom communities of 10,000 people and by Millville and other industrial towns where laborers lived. "Here it is . . . and we like it. It's attractive and sensible at the same time. It's pleasant because we've spent a lot of money to make it so. . . ." (© Rogers-Kellogg-Stillson.)

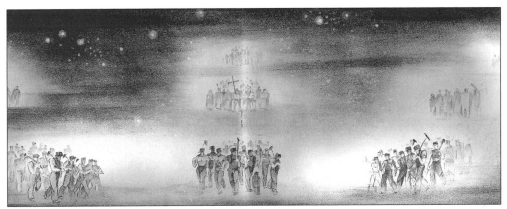

YOUR WORLD OF TOMORROW LIGHT SHOW. Fairgoers not only looked down upon the vast diorama but also looked up to a light show that provided the exhibit's climax: groups of workers, with differing trades, united in purpose. "These giant figures . . . with arms linked . . . priest and farmer and miner and housewife . . . sandhogs and baseball players and telephone operators and ministers . . . dairymen and cotton pickers and brakemen and nurses . . . men and women of all nations. . . . They are marching in triumph. . . . They have triumphed over chaos . . . they have built the World of Tomorrow." (© Rogers-Kellogg-Stillson.)

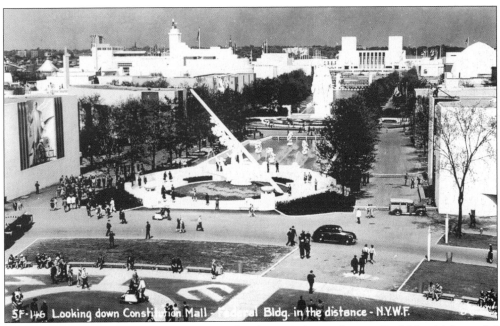

5F-146 Looking down Constitution Mall - Federal Bldg. in the distance - N.Y.W.F.

LOOKING DOWN CONSTITUTION MALL. This dramatic image features Paul Manship's sundial entitled *Time and the Fates of Man*. The work portrays the Greek fates Clotho, Lachesis, and Atropos, who consecutively spun the thread of life, allotted each living thing its individual portion, and cut the thread upon one's death. Described as the largest sundial in the world, this attraction was placed within Constitution Mall near Manship's *Moods of Time* sculptures. (Real-photo postcard; image by Underwood & Underwood.)

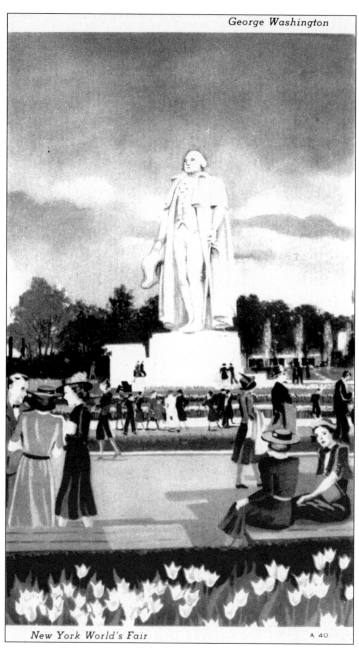

New York World's Fair A 40

GEORGE WASHINGTON. Despite the fair's high-minded talk about tomorrow, its parallel purpose was to commemorate the 150th anniversary of George Washington's inauguration in New York City. To that end, fair planners commissioned James Earle Fraser's 60-foot-tall sculpture of Washington, positioning it atop a 12-foot-high pedestal. Washington's gaze is upon the theme center, and behind the statue, Constitution Mall stretches toward the Lagoon of Nations and the Federal Building. Fraser was one of 35 sculptors who created original works for the fair, each tasked with crafting abstract notions about ideal future into human form. In addition, a number of sculptors lent existing works. (Created for Exposition Souvenir Corporation by Grinnell Litho Company; licensed by New York World's Fair.)

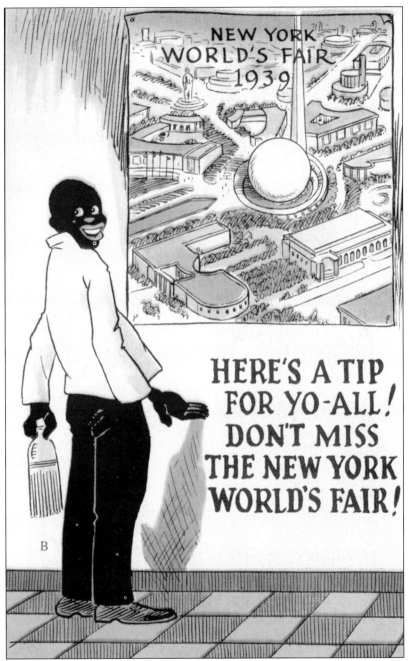

"HERE'S A TIP FOR YO-ALL!" This postcard comes from a collection of World's Fair comics, but its racially insulting depiction is hardly a laughing matter. As was the case in world's fairs of the past, African Americans were conspicuously missing from optimistic visions of the future. Fair planners struggled with civil rights groups to employ them in even the most menial positions, predictably stating that racism was not their problem; the comfort of fair attendees was their only concern. By 1940, the fair allowed a Negro Week in recognition of the fact that African Americans were sure to be asked to participate in the war effort to come. (Image by Tichnor Quality Views.)

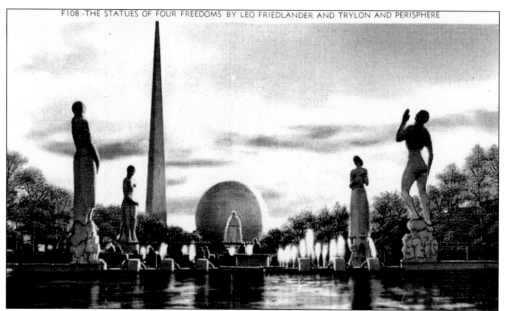

THE MOODS OF TIME. Paul Manship created these sculptures to convey morning, day, evening, and night. Emerging from a democratic school of sculpture, the imagery of the pieces draws from readily identifiable motifs such as the crowing cock to signify morning. Even though the plaster figures were destroyed after the fair, smaller bronze depictions of Manship's figures may be found with a little research. (Created for Exposition Souvenir Corporation by Grinnell Litho Company; licensed by New York World's Fair.)

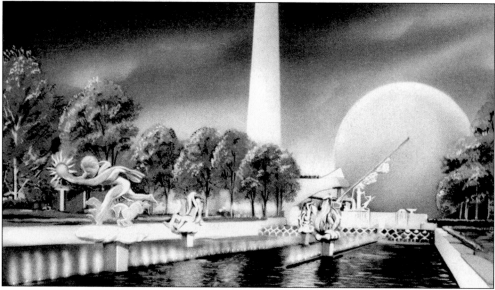

THE FOUR FREEDOMS. Created by Leo Friedlander, these sculptures celebrate the four freedoms of speech, religion, press, and assembly. The works were inspired by the Constitution and were said to have motivated Franklin D. Roosevelt's updated American values in his January 6, 1941, speech of the same name. In that speech, he advocated freedom of speech and worship and also invoked freedom from want and freedom from fear. (Image by Manhattan Post Card Publishing; licensed by New York World's Fair.)

THE WORLD'S FAIR 1940 PAMPHLET. The 1939 World's Fair—gaudy, brash, and awe-inspiring—followed the lead of most of its predecessors and lost money. Some blamed the fair's failure to draw the 40–50 million attendees whom fair planners had envisioned on the heady notion of the fair's theme, *Building the World of Tomorrow.* Reopening in 1940, the fair transformed its motto into *For Peace and Freedom,* a carnival in which regular folks could wander the busy byways of tomorrow but still have fun today. Fair planners lowered the entrance price, dispensed with complicated zones, and emphasized patriotic themes, announcing, "This summer you can go 'abroad at home'—safely, comfortably—along peaceways that emphasize brotherhood, not bombs." (Author's collection.)

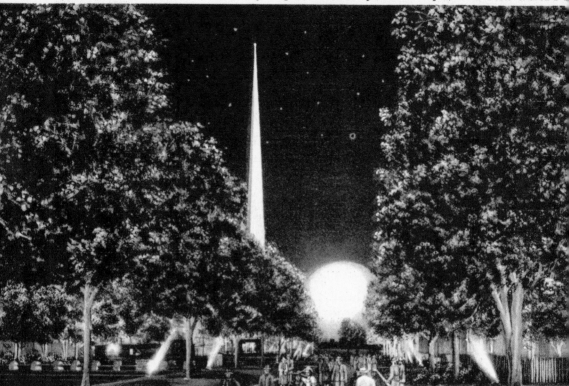

THE TRYLON AND PERISPHERE AT NIGHT. This tranquil scene demonstrates the special lighting techniques employed by fair planners. Writing in *Dawn of a New Day: The New York World's Fair, 1939/40,* Helen A. Harrison describes how designers avoided the use of floodlights, except when lighting the Trylon and Perisphere. Instead, they chose to incorporate subtle and often concealed lighting into the buildings themselves. Informational text on this postcard's reverse adds that even many trees were lit with the aid of capillary mercury tubes hidden in the ground to create a colorful glow throughout the fair. (Image by Interborough News Company; licensed by New York World's Fair; courtesy Lake County, Illinois, Discovery Museum, Curt Teich Postcard Archives.)

PHOTO BY KEYSTONE

PLAZA OF GOVERNMENTS. This is a stylized depiction of the Government Zone. When the fair actually opened on April 30, 1939, Pres. Franklin Roosevelt delivered the world's first televised presidential address from the Plaza of Governments. In his remarks, Roosevelt announced, "America's wagon is still hitched to a star. . . . May the months to come at the fair carry us forward in the rays of that eternal hope." (Image by Tichnor Quality Views.)

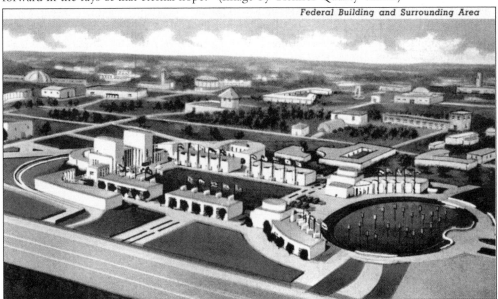

Federal Building and Surrounding Area

THE FEDERAL BUILDING. This is a relatively accurate depiction of the Federal Building, designed and built by Howard L. Cheney. Its twin towers symbolize the judicial and legislative branches of government, and the 13 center pillars represent the 13 original Colonies. Along with murals and displays, this site also offered a free film, *Land of Liberty,* directed by Cecil B. DeMille. (Image by Frank E. Cooper; licensed by New York World's Fair; courtesy Lake County, Illinois, Discovery Museum, Curt Teich Postcard Archives.)

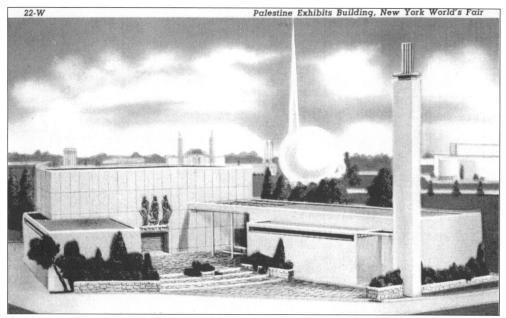

THE JEWISH-PALESTINIAN PAVILION. Placed in the Community Interests Zone between the Beech-Nut and YMCA exhibits, this site celebrated the achievements of Jewish settlers in making a desert bloom. Sidestepping the complexities of such history in the making, the building offered an inspiring account of a hardworking and determined people. It was designed and built by Arieh El-Hanani, Norvin R. Lindheim, and Lee Simonson. (Image by Frank E. Cooper; licensed by New York World's Fair; courtesy Lake County, Illinois, Discovery Museum, Curt Teich Postcard Archives.)

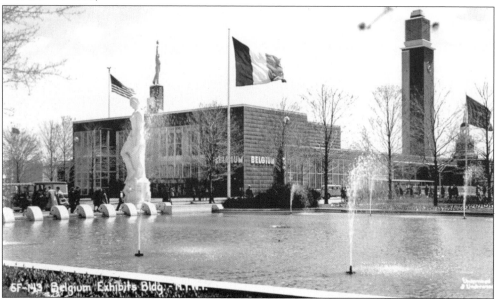

THE BELGIAN PAVILION. The Belgian Pavilion, built by the architectural firm of Van de Velde Stynen and Bourgeois, featured a 155-foot-high tower with a belfry that contained 36 bronze bells. Notable for being entirely air-conditioned, the pavilion offered movies, jewels, fine laces, and a celebration of Belgium's holdings in the Congo. (Image by Underwood & Underwood.)

THE FRENCH PAVILION. The French Pavilion was built by the architectural firm of Expert and Patout at a cost of some $4 million. It featured two stories dedicated to the intellectual pursuits, cultural artifacts, and culinary achievements of France. Renowned for its uncompromising haute cuisine, the popular terrace restaurant offered an impressive array of high-quality food and wine, with accompanying high-quality prices. (Real-photo postcard; image by Underwood & Underwood; courtesy of Richard Musante.)

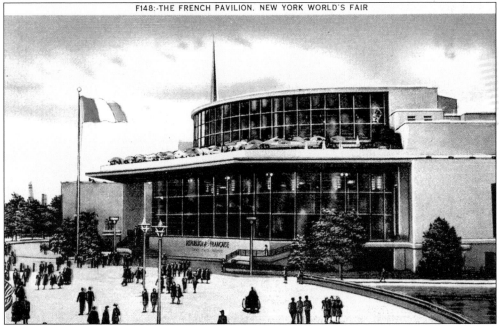

ANOTHER VIEW OF THE FRENCH PAVILION. Adjacent to Constitution Mall, the French Pavilion was situated close enough to the Lagoon of Nations for its patrons to enjoy the fireworks shows that dazzled fairgoers nightly. (Linen postcard; image by Manhattan Post Card Publishing; licensed by New York World's Fair.)

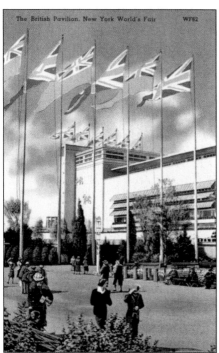

THE BRITISH PAVILION. The two buildings of the British Pavilion displayed an impressive collection of artifacts, including an original text of the Magna Carta, a replica of the Crown Jewels, and coins from the Royal Mint. This pavilion was built by Stanley Hall and designed by Easton & Robertson. (Created for Exposition Souvenir Corporation by Grinnell Litho Company; licensed by New York World's Fair.)

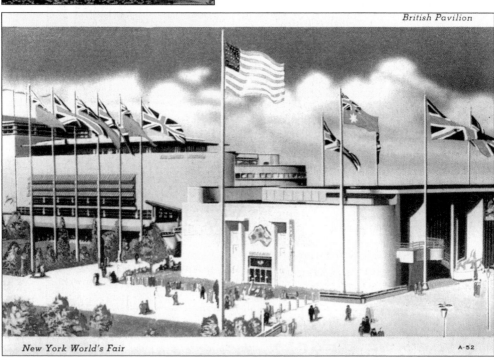

THE BRITISH PAVILION WITH FLAGS. In June 1939, King George VI became the first British royal to visit the United States, meeting Pres. Franklin Roosevelt and enjoying the hospitality of 3.5 million New Yorkers who lined the streets in welcome. Naturally, the royal entourage toured the British Pavilion at the New York World's Fair. (Image published by Tichnor Quality Views; licensed by New York World's Fair; courtesy of Richard Musante.)

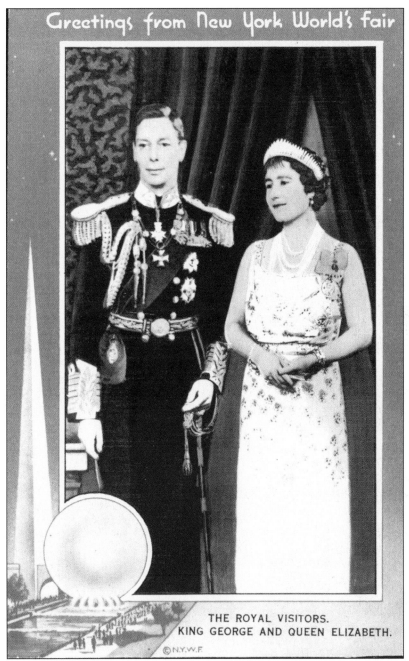

Greetings from New York World's fair

THE ROYAL VISITORS.
KING GEORGE AND QUEEN ELIZABETH.

©N.Y.W.F.

KING GEORGE AND QUEEN ELIZABETH. The royal visit to the fair was part of a five-day tour hosted by the Roosevelts to demonstrate Anglo-American solidarity and to drum up support for the Lend-Lease Act, a hard sell given strong isolationist sentiments throughout the heartland. One strategy employed by both sides was to demonstrate that the royals were "just folks." Perhaps this appeal could not have been made more effectively than with a picnic in Hyde Park at which the Roosevelts served hot dogs. Although some decried the tacky nature of the gesture, the royals were said to be delighted with the delicacy. (Image by Miller Art Company; licensed by New York World's Fair.)

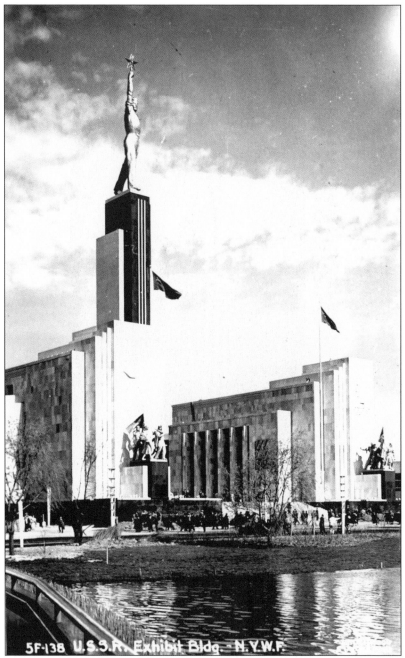

5F-138 U.S.S.R. Exhibit Bldg. - N.Y.W.F.

THE SOVIET PAVILION. The Soviet Union was represented by three buildings at the fair, including the Arctic Pavilion, and by a small display in the Foreign Exhibits Building. The main pavilion drew the most attention, with its bombastic steel figure, *The New Soviet Citizen,* created by Vyacheslav Andreyev. Standing amidst the semicircular building, with both wings depicting relief figures of Lenin and Stalin, the figure was nicknamed "Big Joe" and, less affectionately, "the Bronx Express Straphanger." By the 1940 season, the Soviets had aligned themselves with Nazi Germany and pulled out of the fair; their pavilion was razed and transformed into the American Common to celebrate the power of free speech. (Image by Underwood & Underwood.)

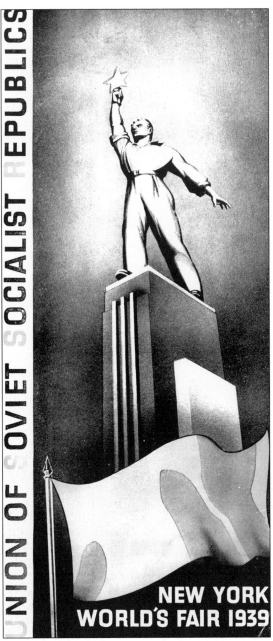

A SOVIET PAMPHLET. According to this pamphlet, the Soviet Union represented a brave new world in which the people had "ended exploitation of men by men, eliminated racial and national animosities and in which 170,000,000 people of different nationalities are united in a voluntary, equal federation of eleven Socialist Republics." Visitors also learned that the Soviet Union, "by nature," could never face the kinds of economic troubles that hobbled much of the world during the 1930s. The pamphlet also previewed a diorama that demonstrated the glorious new Soviet age by transforming a landlord's mansion and a depressing saloon into a collectivist farm and cheerful kindergarten. At the Soviet Pavilion, even the model subway station was a worker's paradise. (Author's collection.)

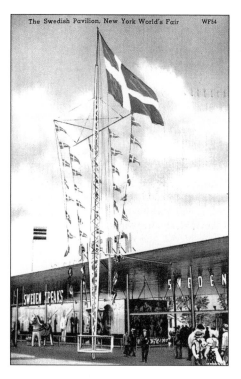

THE SWEDISH PAVILION. This pavilion was placed somewhat distant from the other Government Zone structures. In fact, fairgoers had to hunt for this building among the Food Zone exhibits. Those who persevered got the chance to sample appetizers from a Swedish smorgasbord and enjoy a collection of cultural arts and crafts. The pavilion was built by Sven Markelius and Simon Breines. (Image by Tichnor Quality Views; licensed by New York World's Fair.)

THE ROMANIAN PAVILION. This four-story marble house showcased the handicrafts and peasant festivals of Romania, not to mention a gypsy chorus. The 1939 *Guide Book* condescendingly remarked that the nation "strives to become known as a nation of mighty toilers." The building was constructed by architects Prince George Cantacuzino, Octav Doicescu, and Aurel Doicescu. (Image published by Photo Seal; courtesy of Richard Musante.)

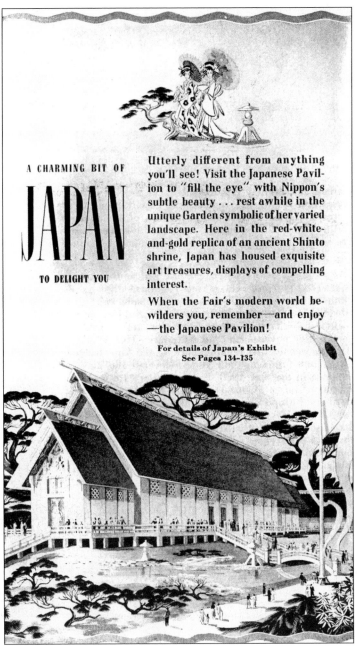

A CHARMING BIT OF

JAPAN

TO DELIGHT YOU

Utterly different from anything you'll see! Visit the Japanese Pavilion to "fill the eye" with Nippon's subtle beauty . . . rest awhile in the unique Garden symbolic of her varied landscape. Here in the red-white-and-gold replica of an ancient Shinto shrine, Japan has housed exquisite art treasures, displays of compelling interest.

When the Fair's modern world bewilders you, remember—and enjoy—the Japanese Pavilion!

For details of Japan's Exhibit
See Pages 134–135

AN ADVERTISEMENT FOR THE JAPANESE PAVILION. This advertisement from the 1939 *Guide Book* demonstrated a significant mission of the fair's "parliament of nations." In its introduction of the Government Zone, the book notes the importance of cultural displays such as Japan's exhibit. Illustrating once more the typically idealistic orientation of the whole exercise, the prose offers a compelling reason to visit: "The Fair is a force for peace in the world; for without peace the dream of a better 'World of Tomorrow' is but a cruel and mocking illusion." Despite these utopian longings, one year after the fair closed the United States was at war with Japan and its European Axis partners. (Author's collection.)

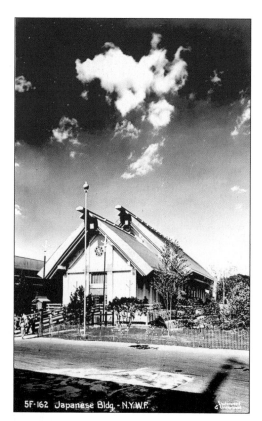

THE JAPANESE PAVILION. This building featured a tea ceremony and flower arranging exhibits, along with historical displays covering 2,600 years of Japanese history. Y. Utida and Yatsuo Matsui designed the site to evoke images of a traditional Shinto shrine colored in red, white, and gold. The pavilion was further augmented with a garden planned by Shogo Myaida. (Image by Underwood & Underwood.)

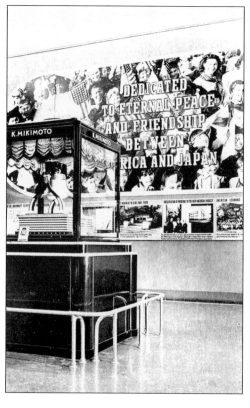

THE DIPLOMAT ROOM OF THE JAPANESE PAVILION. In an era of increasing tensions between the empire of Japan and the West, the pavilion offered a glimpse across cultures. Most notably, visitors to the Diplomat Room could gaze upon a Liberty Bell replica that was made from Japanese pearls and diamonds worth $1 million. (Created by Albertype; © K. Tenniti.)

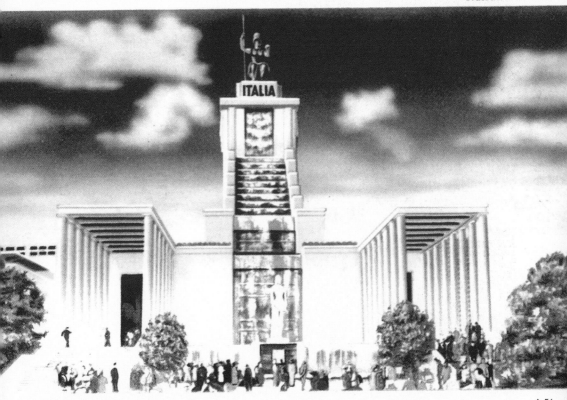

THE ITALIAN PAVILION. Created by architect Michele Busiri-Vici, this imposing structure boasted a statue of the goddess Roma and a 200-foot-high waterfall that pumped eight million gallons a day toward a figure of Guglielmo Marconi, the inventor of radio. The pavilion recounted two millennia of Italian history from the age of the Caesars to its "renaissance" under the regime of Benito Mussolini. Visitors touring the first floor were treated with displays of Italy's industrial might and progress achieved through *autarchia,* or self-sufficiency. Visitors to the second floor found exhibits of Italy's explorers and colonial holdings, along with a restaurant and nightclub. (Created for Exposition Souvenir Corporation by Grinnell Litho Company; licensed by New York World's Fair.)

41

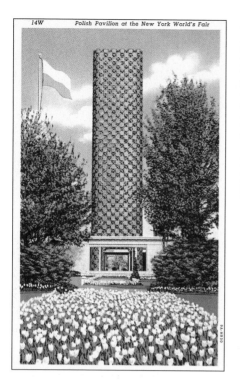

THE POLISH PAVILION. With its stark 141-foot-high tower, this pavilion grabbed the attention of passersby. Inside the pavilion, created by architects Jan Cybulski and Jan Galinowiski, visitors surveyed Polish inventions and sampled hors d'oeuvres at an adjacent bar. Sadly, the cultural displays of this pavilion were overshadowed by events in Europe, as Nazi Germany invaded Poland in September 1939. (Image by Frank E. Cooper; licensed by New York World's Fair; courtesy Lake County, Illinois, Discovery Museum, Curt Teich Postcard Archives.)

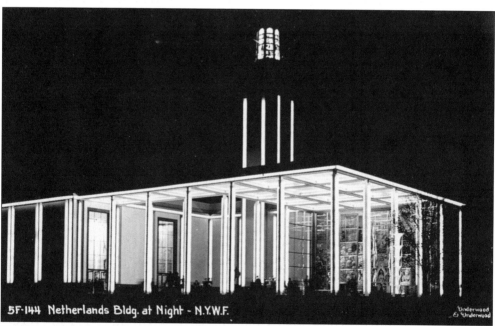

THE NETHERLANDS PAVILION AT NIGHT. Celebrating the kingdom's possessions in Europe, the East Indies, and South America, the Netherlands Pavilion also presented a burst of color in the form of 65,000 tulips. Given the Nazi invasion of Holland on May 10, 1940, it is not surprising that the *Guide Book* of that year offers little insight into the operation of the Netherlands exhibit in the fair's second season. (Image by Underwood & Underwood.)

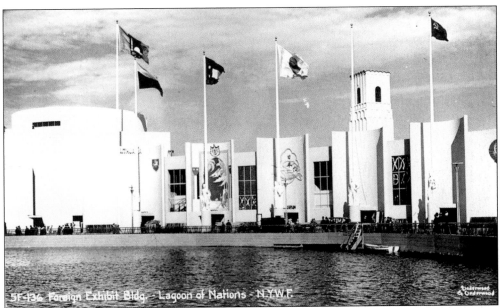

THE FOREIGN EXHIBITS BUILDING. The modern era of world's fairs began with the 1851 Crystal Palace Exposition, in which nations gathered to demonstrate their cultures and, of course, their consumables. Despite the Depression that lingered throughout the world, that tradition continued in 1939, as 60 nations spent some $35 million to build pavilions. In the Foreign Exhibits Building, some smaller displays such as those from Lithuania could be found partially circling the Lagoon of Nations. (Image by Underwood & Underwood.)

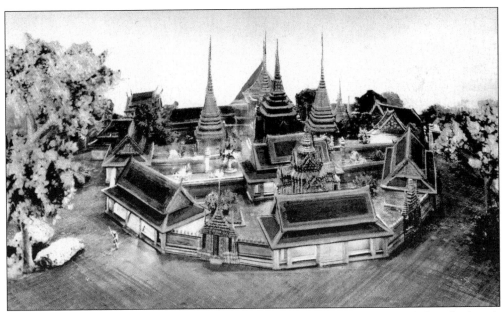

THE SIAMESE PAVILION. Occupying a relatively small space in the Hall of Nations (North, though it is labeled South in some guides), the Siamese exhibit displayed artifacts of the cultural practices and agricultural life of Siam, which changed its name to Thailand in 1939. Visitors could view a diorama of Bangkok's Wat Po Temple. (Created by Albertype; courtesy of Richard Musante.)

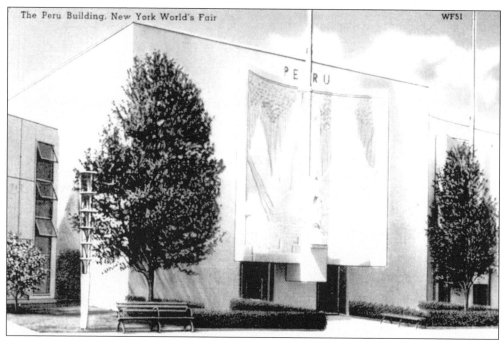

THE PERUVIAN PAVILION. Located adjacent to the Swiss Pavilion behind Presidential Row North, Peru's exhibit showcased the nation's 3,000-year-old Inca legacy with mummies and other artifacts. The building's entrance facade also demonstrated a modern appreciation for Art Deco relief sculpture. (Image published by Tichnor Brothers; licensed by New York World's Fair.)

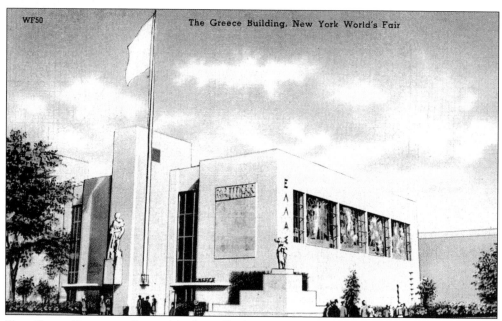

THE GREEK PAVILION. Located in the Hall of Nations (South), the Greek Pavilion depicted art and literature from ancient Greece and shared the many foods, silks, and other exports of the Hellenic republic. (Image published by Tichnor Brothers; licensed by New York World's Fair.)

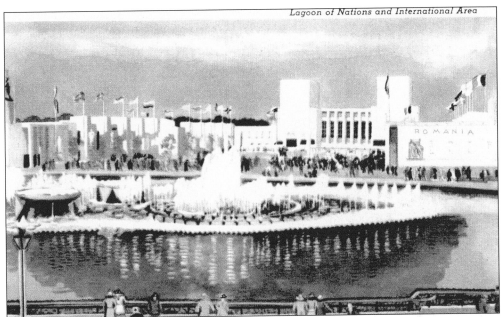

THE LAGOON OF NATIONS AND THE INTERNATIONAL AREA. Fair planners loved fountains and sought to employ enchanting combinations of water, music, and light wherever possible. While their original plans to create the illusion of gushing water holding the Perisphere aloft proved to be infeasible, they managed to create a spectacular exhibit in the Lagoon of Nations, located between Constitution Mall and the Court of Peace. (Image created for Exposition Souvenir Corporation by Grinnell Litho Company; licensed by New York World's Fair.)

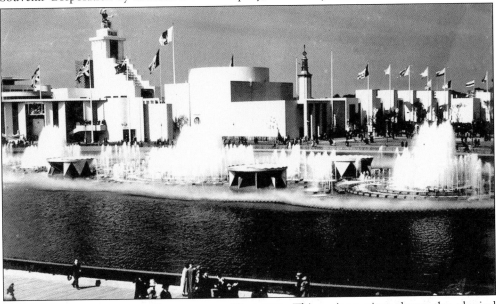

THE FOUNTAINS IN THE LAGOON OF NATIONS. This unique view shows the physical proximity of several national pavilions located near the Lagoon of Nations. From left to right are the British, Italian, and Netherlands Pavilions. (Real-photo postcard; image by Underwood & Underwood for Manhattan Post Card Publishing; licensed by New York World's Fair; courtesy of Richard Musante.)

45

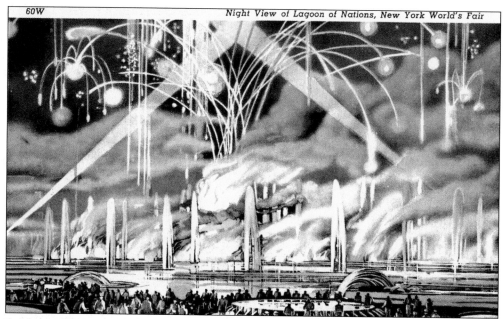

A Night View of the Lagoon of Nations. At night, fairgoers enjoyed a series of water and light symphonies designed by Jean Labatut and composer Robert Russell Bennett. This postcard describes the combination as one of Niagara and Vesuvius. (Image by Frank E. Cooper; licensed by New York World's Fair; courtesy Lake County, Illinois, Discovery Museum, Curt Teich Postcard Archives.)

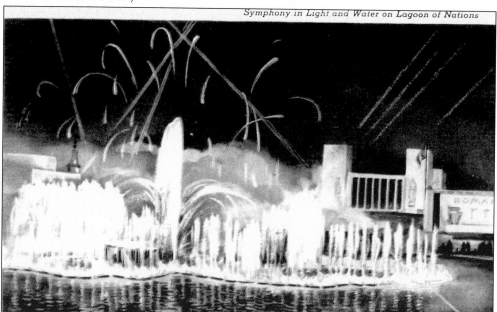

Symphony in Light and Water on Lagoon of Nations

A Symphony in Light and Water. The water symphonies demonstrated the power of technology to tame natural forces with the aid of some 1,400 powerful jets capable of creating bursts of water some 150 feet high. Lit by searchlights, fireworks, and other effects, the Lagoon of Nations offered a spectacular conclusion to a summer's night. (Created for Exposition Souvenir Corporation by Grinnell Litho Company; licensed by New York World's Fair.)

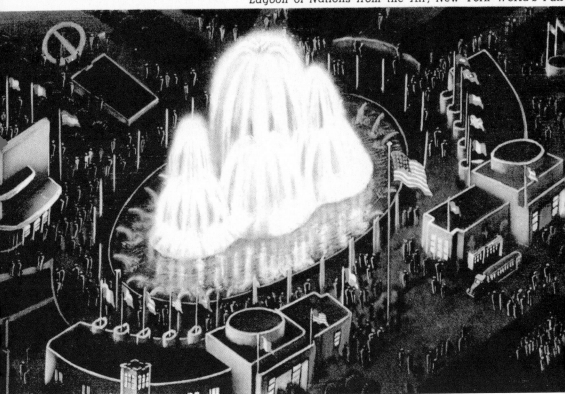

An Overhead View of the Lagoon of Nations at Night. From this perspective, the international section of the Government Zone is in the distance while spectators at the Lagoon of Nations enjoy a water, music, and light show, dedicated, perhaps, to George Washington. The 1939 *Guide Book* describes the show: "vast jets of water, flame, and pyrotechnics shower the darkness with unique designs—reds, greens, yellows, blues, and sparkling silver against the background of the night." (Image by Interborough News Company; licensed by New York World's Fair; courtesy Lake County, Illinois, Discovery Museum, Curt Teich Postcard Archives.)

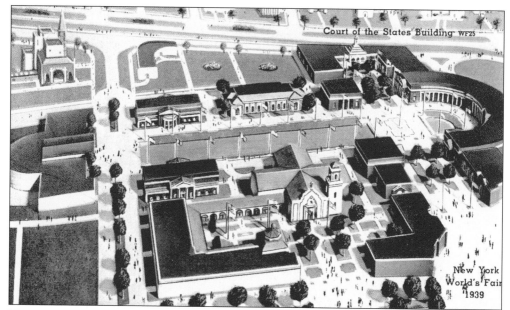

THE COURT OF STATES. Most of the fair's state exhibits were located in a Colonial-style series of exhibits adjacent to World's Fair Boulevard. As a celebration of American culture that had emerged since George Washington's inauguration, the Court of States eschewed the modernistic architecture that dominated most of the fair. In this projected view, note the absence of the distinctive spires of the focal building and the Pennsylvania Building. (Image published by Tichnor Brothers; licensed by New York World's Fair.)

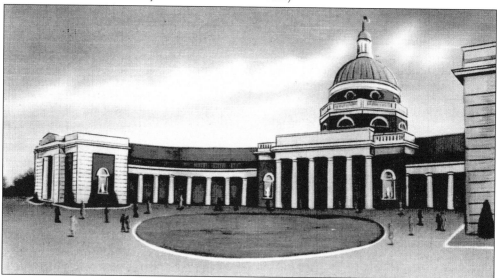

THE SOUTH BUILDING OF THE COURT OF STATES. This site featured exhibits from Maine, Arizona, North Carolina, and Puerto Rico. Its centerpiece, the Virginia Room, presented a quiet abode, complete with a charming fountain and rows of photograph albums depicting the beauty and industry of Old Dominion. Unlike so many lost exhibits of the fair, this exhibit can be remembered through the Library of Virginia, which maintains an online collection of these images. (Created for Exposition Souvenir Corporation by Grinnell Litho Company; licensed by New York World's Fair.)

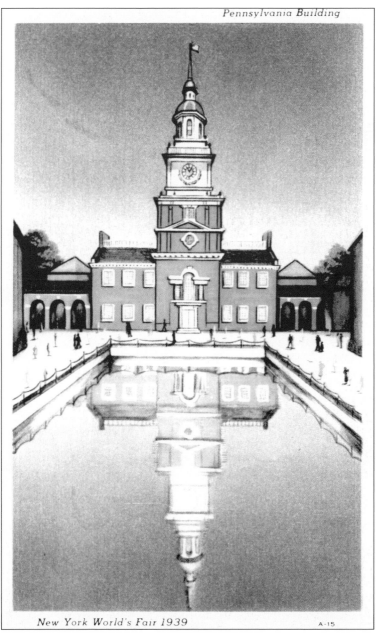

Pennsylvania Building

New York World's Fair 1939

A-15

THE PENNSYLVANIA BUILDING OF THE COURT OF STATES. This building presented a full-sized reproduction of Philadelphia's Independence Hall, where the Declaration of Independence and Constitution of the United States were ratified. The site also included a replica of the Liberty Bell (but not of pearls and diamonds as in the Japanese Pavilion version) and three main halls dedicated to democracy, tradition, and progress. Unlike the future-oriented structures that defined the fair, this historically themed exhibit offered an example of "edutainment"—a blurring of learning and fun—that emerged more consistently in later amusement parks seeking to entertain and sell consumer goods within themed cultural experiences. (Image created for Exposition Souvenir Corporation by Grinnell Litho Company; licensed by New York World's Fair; courtesy of Richard Musante.)

THE FLORIDA BUILDING. Located on the western shore of Fountain Lake (renamed Liberty Lake in 1940), this building offered a beach-side attraction and carillon tower for visitors of the Amusement Zone. Featuring 6,000 native plants and a talking Ponce de Leon statue, the Florida Building depicted the Sunshine State (fair planners used the lesser known nickname Land of Flowers) in its pre-air-conditioned beauty. It was built by the architectural firm of Paist and Steward. (Created for Exposition Souvenir Corporation by Grinnell Litho Company; licensed by New York World's Fair.)

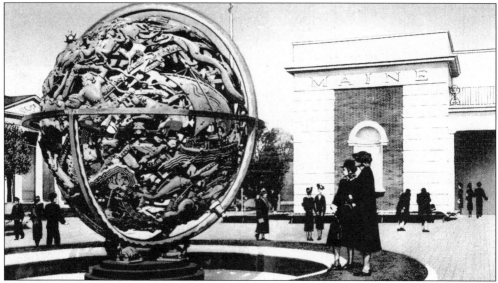

THE CELESTIAL SPHERE. Paul Manship's sculpture reproduces the original sphere, built as an homage to Woodrow Wilson. Positioned in the Court of States, the piece depicts a bronze globe filled with humanity's strivings, longings, and conflicts, all astride four turtles. Today, *The Celestial Sphere* resides near the United Nations European offices in Geneva, Switzerland. (Image by Frank E. Cooper; licensed by New York World's Fair; courtesy Lake County, Illinois, Discovery Museum, Curt Teich Postcard Archives.)

Two

MOVING IDEAS IN THE WORLD OF TOMORROW

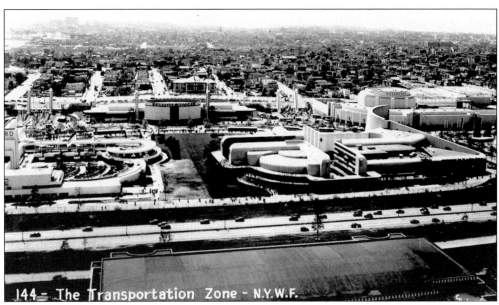

TRANSPORTATION ZONE. This stunning 1940 view depicts the Transportation Zone, dedicated to celebrating America's newfound age of mobility. This view looks over the New York City Building and the Grand Central Parkway. Behind stands the Trylon and Perisphere. Beyond the road are, from left to right, the Ford Building, the Chrysler Building, the General Motors Building, and the Railroad Building. (Real-photo postcard; image by Underwood & Underwood; licensed by New York World's Fair.)

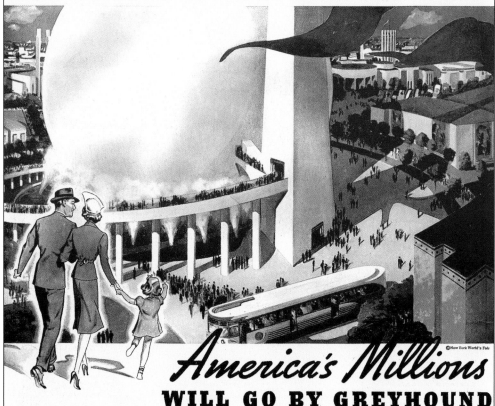

NEW YORK WORLD'S FAIR 1939

©New York World's Fair

America's Millions
WILL GO BY GREYHOUND

APRIL 30th is a red-letter day on America's calendar—for it ushers in the most tremendous show of all history—the New York World's Fair! Today—even before the finishing touches—it is an incredible dream city, stretching for miles in the fantastic designs of tomorrow's architecture, glowing with multi-colored murals. But try to picture it on opening night, and every week and month of gay activity thereafter—echoing to the tramp

and laughter of the world's millions—flaming with many billion candle-power of rainbow lights. In his heart, every American has said, *"I'm going!"* Greyhound can help make that promise come true —for it is the one and only transportation system that can take people from every quarter of America *to the Fair—through the Fair—at the lowest fare. TO THE FAIR:* in famous Greyhound Super-

Coaches, world's most comfortable highway vehicles —modern miracles of smooth-riding travel ease. *THROUGH THE FAIR:* in special Greyhound Exposition buses—streamlined grandstands on wheels! *AT THE LOWEST FARE:* a saving of many dollars, from almost any part of the United States or Canada. Start planning your trip by Greyhound. It's the one way to see America best—going to the Fair by one picturesque route, returning another, at no extra cost.

Mail Coupon to Nearest of these Greyhound Offices

CLEVELAND, O. East 9th & Superior
PHILADELPHIA, PA. . . Broad Street Station
NEW YORK CITY 245 West 50th St.
CHICAGO, ILL. 12th & Wabash
BOSTON, MASS. 60 Park Square
WASHINGTON, D. C.
. 1403 New York Ave., N.W.
DETROIT, MICH.
. Washington Blvd. at Grand River
ST. LOUIS, MO. . . Broadway & Delmar Blvd.
CHARLESTON, W. VA. 155 Summers St.
RICHMOND, VA. 412 E. Broad St.

SAN FRANCISCO, CAL. . . Pine & Battery Sts.
FT. WORTH, TEX. 905 Commerce St.
MINNEAPOLIS, MINN. . . 509 Sixth Ave., N.
MEMPHIS, TENN. 527 N. Main St.
NEW ORLEANS, LA. 400 N. Rampart St.
LEXINGTON, KY. 801 N. Limestone
CINCINNATI, O. 630 Walnut St.
WINDSOR, ONT. 403 Ouellette Ave.
JOHANNESBURG, S. AFRICA
. Perry, Leon & Hayhoe, Ltd.
LONDON, ENGLAND
. . . A. B. Reynoldson, 49 Leadenhall Street

The
GREYHOUND
LINES

Get Your Copy of Bright Pictorial World's Fair Booklet

Would you like a free booklet chock-full of New York City and World's Fair pictures and maps—designed to give you vital and interesting information, all about the Fair? Just mail this coupon to nearest Greyhound information office listed at left.

Name _____

Address _____ SEP-4

"AMERICA'S MILLIONS WILL GO BY GREYHOUND." This is one of the most enchanting advertisements of the fair. A smartly dressed family—the man wearing a jaunty hat and his wife sporting nonsensible shoes—joins the happy throng. The advertisement reads, "In his heart, every American has said, 'I'm going!'" (Licensed by New York World's Fair; the name Greyhound and the running dog are registered trademarks of Greyhound Lines Inc. and are used with permission.)

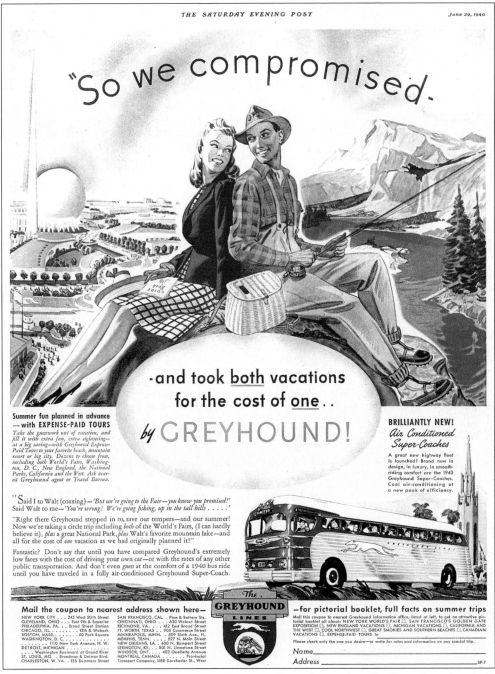

"So we compromised.

-and took **both** vacations for the cost of **one**..

by GREYHOUND!

Summer fun planned in advance — with EXPENSE-PAID TOURS

Take the guesswork out of vacation, and fill it with extra fun, extra sightseeing—at a big saving—with Greyhound Expense-Paid Tours to your favorite beach, mountain resort or big city. Dozens to choose from, including both World's Fairs, Washington, D. C., New England, the National Parks, California and the West. Ask nearest Greyhound agent or Travel Bureau.

BRILLIANTLY NEW!
Air Conditioned Super-Coaches

A great new highway fleet is launched! Brand new in design, in luxury, in smooth-riding comfort are the 1940 Greyhound Super-Coaches. Cool air-conditioning at a new peak of efficiency.

"*Said I to Walt (coaxing)—'But we're going to the Fair—you know you promised!' Said Walt to me—'You're wrong! We're going fishing, up in the tall hills.....*'

"Right there Greyhound stepped in to, save our tempers—and our summer! Now we're taking a circle trip including *both* of the World's Fairs, (I can hardly believe it), *plus* a great National Park, *plus* Walt's favorite mountain lake—and all for the cost of *one* vacation as we had originally planned it!"

Fantastic? Don't say that until you have compared Greyhound's extremely low fares with the cost of driving your own car—or with the rates of any other public transportation. And don't even *guess* at the comfort of a 1940 bus ride until you have traveled in a fully air-conditioned Greyhound Super-Coach.

Mail the coupon to nearest address shown here—

NEW YORK CITY . . . 245 West 50th Street
CLEVELAND, OHIO . . . East 9th & Superior
PHILADELPHIA, PA. . . Broad Street Station
CHICAGO, ILL. 12th & Wabash
BOSTON, MASS. 60 Park Square
WASHINGTON, D. C.
. 1110 New York Avenue, N. W.
DETROIT, MICHIGAN
. . . Washington Boulevard at Grand River
ST. LOUIS, MO. . . Broadway & Delmar Blvd.
CHARLESTON, W. VA. . 155 Summers Street

SAN FRANCISCO, CAL. . Pine & Battery Sts.
CINCINNATI, OHIO . . . 630 Walnut Street
RICHMOND, VA. . . . 412 East Broad Street
FT. WORTH, TEXAS . . 905 Commerce Street
MINNEAPOLIS, MINN. . 509 Sixth Ave., N.
MEMPHIS, TENN. 527 N. Main Street
NEW ORLEANS, LA. . . 400 N. Rampart Street
LEXINGTON, KY. . . 801 N. Limestone Street
WINDSOR, ONT. . . . 403 Ouellette Avenue
MONTREAL, CANADA Provincial
Transport Company, 1188 Dorchester St., West

The GREYHOUND LINES

—for pictorial booklet, full facts on summer trips

Mail this coupon to nearest Greyhound information office, listed at left, to get an attractive pictorial booklet all about: NEW YORK WORLD'S FAIR □, SAN FRANCISCO'S GOLDEN GATE EXPOSITION □, NEW ENGLAND VACATIONS □, MICHIGAN VACATIONS □, CALIFORNIA AND THE WEST □, COOL NORTHWEST □, GREAT SMOKIES AND SOUTHERN BEACHES □, CANADIAN VACATIONS □, EXPENSE-PAID TOURS □.

Please check only the one you desire—or write for rates and information on any special trip.

Name _____

Address _____ SP-7

"SO WE COMPROMISED." West Coast old-timers often talk nostalgically about the other 1939 fair, held on Treasure Island near San Francisco. Train and bus companies were more than willing to help folks find a way to see both. The wife in this advertisement gleefully announces, "Greyhound stepped in to save our tempers—and our summer! Now we're taking a circle trip including *both* of the World's Fairs (I can hardly believe it), *plus* a great National Park, *plus* Walt's favorite mountain lake. . . ." (The name Greyhound and the running dog are registered trademarks of Greyhound Lines Inc. and are used with permission.)

CORONA GATE SOUTH. Passing through these gates, visitors looking to the right saw the oddly shaped Aviation Building, which resembled a mushroom in space (although its planners sought to inspire visions of airplanes in flight). Beyond, the twin blue prows of the Marine Transportation Hall rose toward the sky. Benjamin Hawkins's *Samson and the Lion* sculpture was also nearby. (Image by Manhattan Post Card Publishing; licensed by New York World's Fair.)

New York World's Fair 1939 A-37

CORONA GATE NORTH. Entering the fair through these towering pylons, fairgoers could choose to visit the mammoth Railroad Building to their left, the Chrysler Motors Building, with its winged towers, to the right, or the General Motors Building straight ahead. Also gracing the gate, Rene P. Chambellan's sculpture *Spirit of the Wheel*. (Image created for Exposition Souvenir Corporation by Grinnell Litho Company; licensed by New York World's Fair.)

THE CHRYSLER MOTORS BUILDING. James Gamble Rodgers was the architect for this building, which included Raymond Loewy's depiction of transportation through the ages. The exhibit began with the trudge of bare feet and concluded with a fanciful rocket ship launching its passengers on a dizzying trip to London. Other attractions included a talking Plymouth automobile, a three-dimensional color film, and a frozen forest. (Image licensed by New York World's Fair; published by American Card, based on a photograph by Underwood & Underwood.)

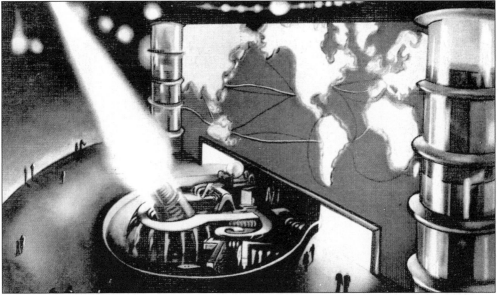

THE ROCKET PORT. The Chrysler Building's rotunda featured a futuristic display of transportation technology reminiscent of Jules Verne's space gun. Viewers who had grown tired of pockmarked roads and endless drives must have marveled at the fair's depiction of space travel for the masses. The 1939 *Guide Book* describes how "a great steel crane moves, a magnet picks up the Rocketship and deposits it into the breach of the rocketgun. A moment of awesome silence. A flash, a muffled explosion, and the ship vanishes into the night." Like many of Raymond Loewy's designs, the rocket gun portrayed a streamlined future of steel transformed into art. (Image created for Exposition Souvenir Corporation by Grinnell Litho Company; licensed by New York World's Fair.)

STANDING ON THE BRIDGE OF WINGS. Facing the Trylon and Perisphere, visitors saw the Electrical Products Building to their right, the Hall of Pharmacy to their left, and the Court of Power straight ahead. Under the bridge, cars raced along Robert Moses's Grand Central Parkway. (Image created for Exposition Souvenir Corporation by Grinnell Litho Company; licensed by New York World's Fair.)

STANDING ON THE BRIDGE OF WHEELS. With their backs to the Trylon and Perisphere, visitors gazed upon the largest structure of the fair. Sponsored by the Eastern Railroads Presidents Conference, the Railroad Building and Yards celebrated the role of locomotives in American history and industry. Edward Hungerford's *Railroads on Parade* depicted the progress of the iron horse over old-fashioned horsepower with the help of 250 actors and 20 trains. (Image by Underwood & Underwood; licensed by New York World's Fair.)

RAILROADS AT THE NEW YORK WORLD'S FAIR. Not only did the Eastern Railroad Presidents Conference sponsor create a 17-acre building, complete with 4,500 feet of track, it also offered some pretty impressive deals for those who did not want to take the bus across country to see both world's fairs. For $90, intrepid travelers could buy a round-trip ticket from their home stations and see both the New York World's Fair and the Golden Gate International Exposition. (Author's collection.)

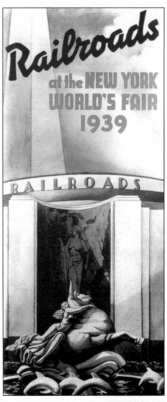

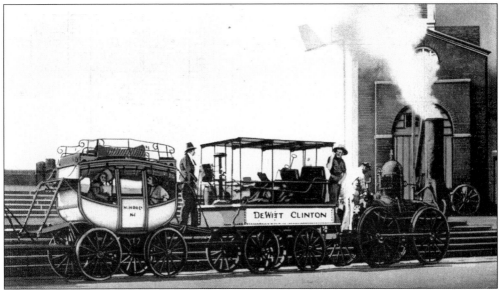

RAILROADS ON PARADE. One of the exhibits sponsored by the Eastern Railroad Presidents Conference, this 16-acre attraction portrayed the history of American locomotives with the aid of a 30-piece orchestra. The postcard pokes fun at the air-conditioning needs of fairgoers by noting how passengers of the *DeWitt Clinton* "got plenty of oxygen—along with a vast amount of soot and cinders." (Image by Frank E. Cooper; licensed by New York World's Fair; courtesy Lake County, Illinois, Discovery Museum, Curt Teich Postcard Archives.)

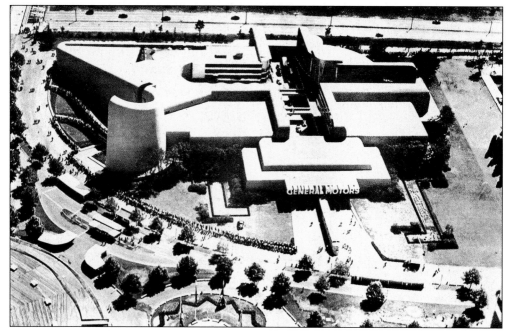

An Overhead View. The architect of this site, Albert Kahn, built more than 1,000 buildings for Ford and hundreds more for General Motors, including its headquarters in 1923. An innovator in the use of reinforced concrete, Kahn strove to create clean, open spaces. His namesake firm endures today, offering planning, design, and management services. (Image from *See the New York Worlds Fair . . . In Pictures*; © Rogers-Kellogg-Stillson.)

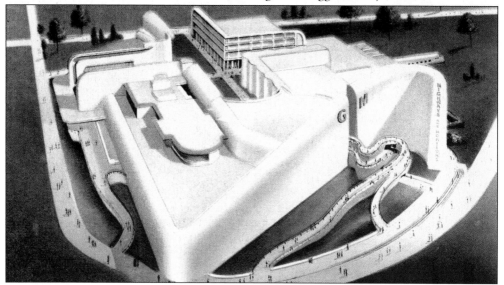

The General Motors Building. The General Motors Building (actually four separate buildings) offered one of the most spectacular sites of the fair. With its towering silver entranceway and concluding promise that "I have seen the future," this celebration of America's emerging Autopia inspired a million suburban dreams. It was created by Albert Kahn Inc. (Image by Frank E. Cooper; licensed by New York World's Fair; courtesy Lake County, Illinois, Discovery Museum, Curt Teich Postcard Archives.)

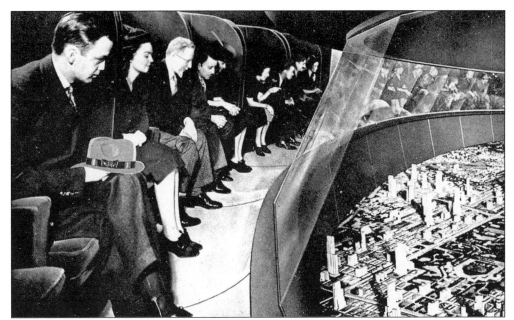

GENERAL MOTORS HIGHWAYS AND HORIZONS. Visitors to the Futurama who had endured the long lines that crawled around the General Motors Building sat down, at last, in one of 552 "sound chairs" that made a one-third-mile circuit through the exhibit. A pamphlet of the exhibit boasts that 28,000 fairgoers a day toured the future thanks to Futurama. Historians recall that 25 million people in all experienced the exhibit. (Image courtesy General Motors Media Archive.)

THE INTERSECTION OF THE FUTURE. Norman Bel Geddes's Futurama offered a ride through 408 dioramas representing the world of 1960, a vision of highways and city planning. An excerpt from a 1939 General Motors Highways and Horizons pamphlet describes Futurama as "a dramatic illustration of how, through continued progress in highway design and construction, the usefulness of the motor car may still be further expanded and the industry's contributions to prosperity and better living be increased." (Image courtesy General Motors Media Archive.)

A BRIDGE VIEW. Futurama focused the audience's attention on a futuristic city of 1960, remarkable for its cloverleaf highways and teardrop automobiles that could race at speeds up to 50 miles an hour. A by-product of this promise of highway design at public expense, beyond the obvious sales of General Motors cars, was the abolition of undesirable slum areas, a harbinger of 1960s-era urban renewal. (Image courtesy General Motors Media Archive.)

A CITY VIEW. As enthralled fairgoers peered into the future, the narrator intoned, "Here you see a closeup view of one section of the great metropolis of 1960. The traffic system is the result of exhaustive surveys of the highway and street problems of the past. Modern and efficient city planning—breath-taking architecture—each city block a complete unit in itself. Broad, one-way thoroughfares—space, sunshine, light and air." (Image courtesy General Motors Media Archive.)

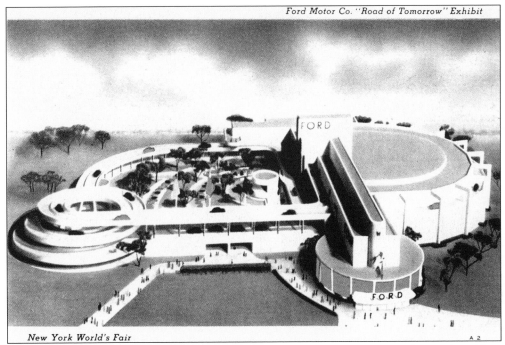

New York World's Fair

THE FORD MOTOR COMPANY BUILDING. Created by Albert Kahn Inc., the Ford Building never inspired the same kind of awe as the General Motors site, but it offered an impressive array of experiences designed by Walter Dorwin Teague. Visitors could view Henry Ford's first car, rest in the Garden Court that featured relaxing music, or ride the half-mile Road of Tomorrow—in a Ford car, of course. (Created for Exposition Souvenir Corporation by Grinnell Litho Company; licensed by New York World's Fair.)

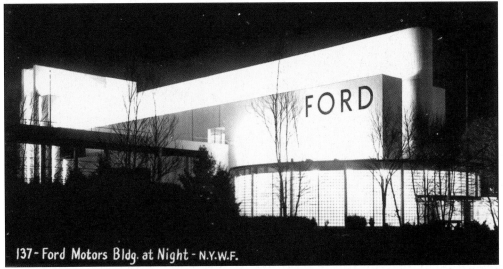

137- Ford Motors Bldg. at Night - N.Y.W.F.

THE FORD MOTOR COMPANY BUILDING AT NIGHT. Representing a "high thirties" motif of streamlined design, the Ford Motor Company Building displays sans serif font, wind tunnel curves of brick glass, and a dramatically sparse facade—a perfect example of an era in which buildings were constructed to resemble Buck Rogers rocket ships. (Real-photo postcard; licensed by New York World's Fair.)

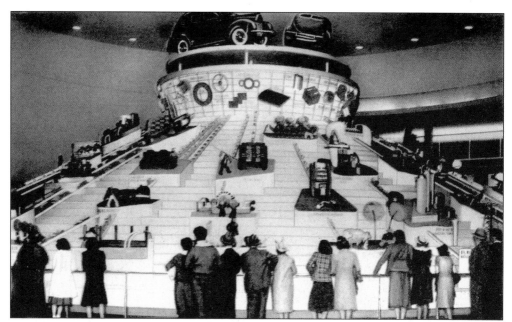

THE FORD CYCLE OF PRODUCTION. This Industrial Hall rotating exhibit demonstrated how Ford technology converted raw materials into the finished product. The 1940 *Fair Guide* offers an oddly sociological description of "how soy beans are converted into plastics and into cloth. Hub caps are stamped out on a huge press . . . and Henry Ford Trade School boys work out their problems at machines." (Created for Exposition Souvenir Corporation by Grinnell Litho Company; licensed by New York World's Fair.)

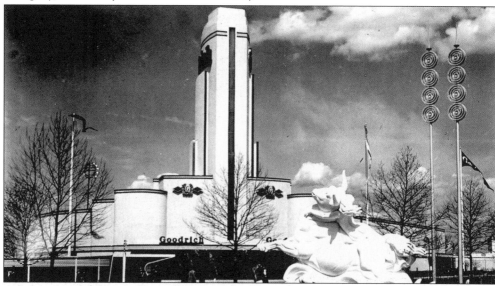

THE B. F. GOODRICH BUILDING. The Goodrich Building offered its visitors a stunning display showing the tenacity of its tires. Designed and built by William Berle Thompson with Wilbur Watson & Associates, the structure had a 90-foot-tall tower that housed a guillotine. The blade of the guillotine fell and bounced off the Goodrich tires. Suitably impressed, visitors could then catch a show by Jimmie Lynch and his stunt drivers in the building's auto track. (Image by Underwood & Underwood; courtesy of Richard Musante.)

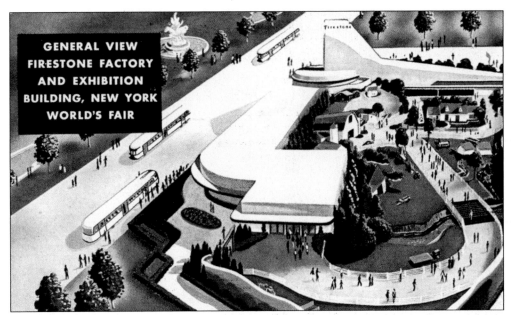

GENERAL VIEW
FIRESTONE FACTORY
AND EXHIBITION
BUILDING, NEW YORK
WORLD'S FAIR

THE FIRESTONE TIRE AND RUBBER COMPANY BUILDING. The Firestone Building featured a display of tire-manufacturing practices, a life-size farm, and a diorama of a Liberian rubber plantation. The structure was designed by George W. McLaughlin and built by architects C. D. Smith, Wilbur Watson, and Associates. The 1940 *Guide Book* emphasized the power of modern planning over exotic locale: "Neat bungalows replace primitive huts, streets supersede forest trails, and electricity pierces the blackness of the African night." (Image © the Firestone Tire & Rubber Company.)

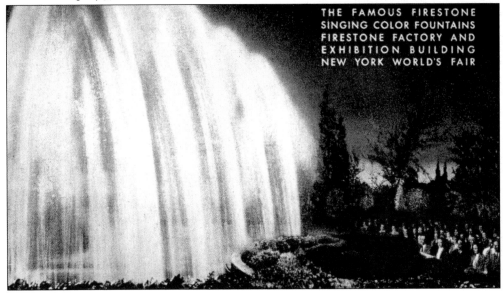

THE FAMOUS FIRESTONE
SINGING COLOR FOUNTAINS
FIRESTONE FACTORY AND
EXHIBITION BUILDING
NEW YORK WORLD'S FAIR

FIRESTONE'S SINGING COLOR FOUNTAINS. Along with the exhibit's displays of rubber plantations and modern technologies, the Firestone Building offered evening concerts of recorded music with lighted fountains. According to the postcard, "The rise and fall of the fountains and the coloration of the lights are controlled by [a] delicate mechanism which is accentuated by the varying wave lengths of the music." (Image © the Firestone Tire & Rubber Company.)

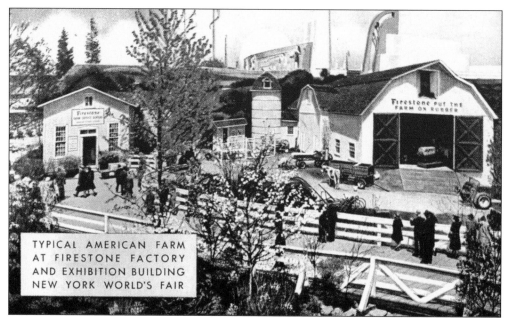

FARMING IN THE WORLD OF TOMORROW. Nestled within the Firestone Building was a modern farm, complete with roaming livestock. The exhibit demonstrated how pneumatic tires aided rural America by ensuring that tractors and other farm equipment ran safely and economically. As the slogan goes, "Firestone Put the Farm on Rubber." (Image © the Firestone Tire & Rubber Company.)

RIDERS OF THE ELEMENTS. This sculpture by Chester Beach sought to demonstrate a common theme of the fair: humanity's use of transportation technologies to overcome the obstacles of nature. Located at the intersection of the Avenue of Transportation and the Court of Ships, the statue offered a calm respite from the frenzied commercialism of the surrounding exhibits. (Image created for Exposition Souvenir Corporation by Grinnell Litho Company; licensed by New York World's Fair.)

THE MARINE TRANSPORTATION HALL. Created by architects Ely Jacques Kahn, William Muschenheim, and Morrison J. Brounn, the Marine Transportation Hall featured twin ocean liners, 80 feet in height. As the 1939 *Guide Book* exclaims, "You can almost imagine these sharp prows slicing through angry seas, whipping up sheets of drenching spray." In the nearby Court of Ships stood Sidney Waugh's *Manhattan* sculpture. (Image by Frank E. Cooper; licensed by New York World's Fair; courtesy Lake County, Illinois, Discovery Museum, Curt Teich Postcard Archives.)

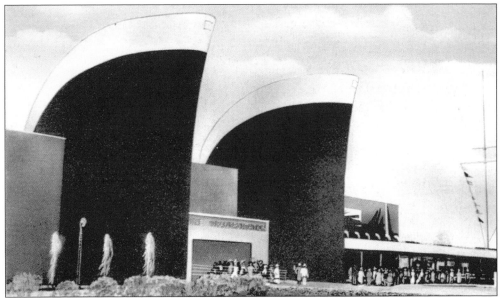

A CLOSEUP OF THE MARINE TRANSPORTATION HALL. Within the building, a world map aided by magnets and wireless communication traced the paths of miniature ships according to their position at sea. The hall offered visitors an impressive display that, nonetheless, failed to generate much of a buzz. For the 1940 iteration of the fair, the marine exhibits were moved to the Communications Building. (Created for Exposition Souvenir Corporation by Grinnell Litho Company; licensed by New York World's Fair.)

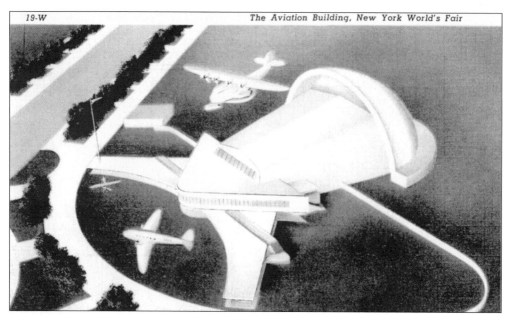

THE AVIATION BUILDING. The Aviation Building, created by architects William Lescaze and James Gordon Carr, sought to portray the experience of flight, complete with an airplane suspended in the hangar. Advertising both the technology and the safety of this new form of transportation, the Aviation Building struggled to attract the crowds drawn by the cars and boats nearby. (Image by Frank E. Cooper; licensed by New York World's Fair; courtesy Lake County, Illinois, Discovery Museum, Curt Teich Postcard Archives.)

A CLOSEUP OF THE AVIATION BUILDING. Seeking to portray a busy urban airport, this structure was considered to be one of the more architecturally ambitious buildings of the fair. Views of its interior can be found in the Museum of the City of New York's book *Drawing the Future.* George W. McLaughlin's delineation was sleek, streamlined, and dramatic. (Image created for Exposition Souvenir Corporation by Grinnell Litho Company; licensed by New York World's Fair.)

THE OPEN ROAD. Situated near the Perisphere in Perylon Court (with its private club), Jo Davidson's sculpture offered a richly detailed meditation on Walt Whitman. Davidson's piece celebrates a poet whose ode to public travel reflects a uniquely American voice: "Afoot and light-hearted I take to the open road / Healthy, free, the world before me / The long brown path before me leading wherever I choose." While not commissioned by the fair planners, the piece provided a contemplative counterpoint to their modernistic motifs of the future. Today, Davidson's Whitman resides near Bear Mountain Zoo in the New York section of the Appalachian Trail. (Image by Frank E. Cooper; licensed by New York World's Fair; courtesy Lake County, Illinois, Discovery Museum, Curt Teich Postcard Archives.)

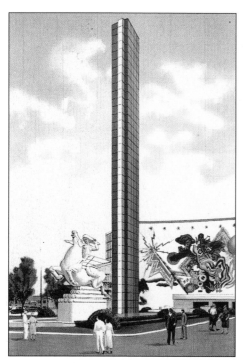

THE COMMUNICATIONS BUILDING. This site, created by architects Francis Keally and Leonard Dean, contained the focal exhibit for the Communication Zone in 1939. By the fair's next season, the building was somewhat ignobly forced to accommodate the maritime transportation exhibits. (Image created for Exposition Souvenir Corporation by Grinnell Litho Company; licensed by New York World's Fair; courtesy of Richard Musante.)

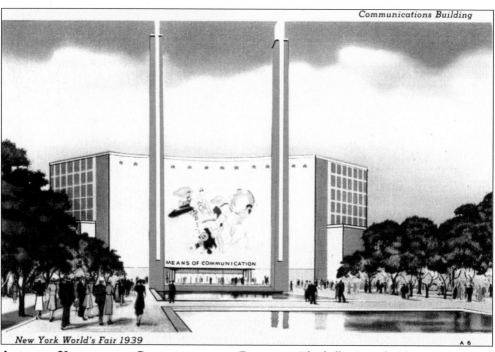

ANOTHER VIEW OF THE COMMUNICATIONS BUILDING. The hall oriented visitors to a court of buildings and exhibits celebrating humankind's mastery of radio, innovation in art, and potential to transform the world through rapid communication. On the facade, Eugene Savage's mural depicted "the Story of Communication." On either side of the building, a 160-foot-high red pylon glowed at night. (Image by Interborough News Company; licensed by New York World's Fair.)

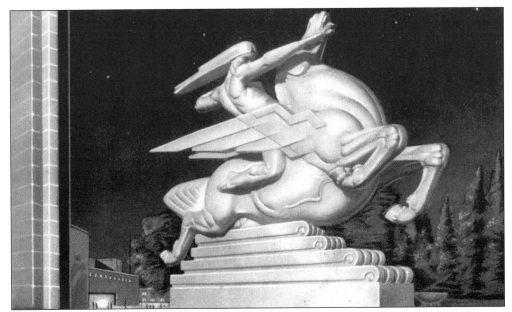

SPEED. Joseph E. Renier's *Speed* statue stood in the Court of Communications as a testament to the power of streamlining. The stylized curves, the etched lines, and the boundless optimism of this statue sought to illustrate the power of communication technologies such as radio and television to overcome and, indeed, annihilate time and space. (Image created for Exposition Souvenir Corporation by Grinnell Litho Company; licensed by New York World's Fair.)

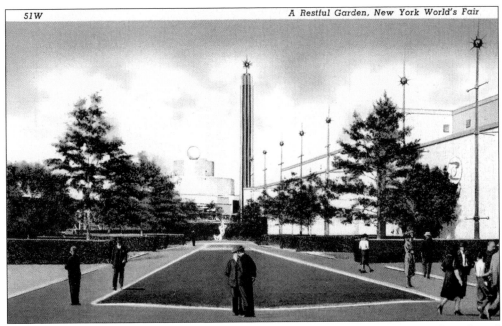

A RESTFUL GARDEN. From this perspective, the Communications Building was to the right and the Cosmetics Building farther along on the left. Straight ahead was the Star Pylon. (Image by Frank E. Cooper; licensed by New York World's Fair; courtesy Lake County, Illinois, Discovery Museum, Curt Teich Postcard Archives.)

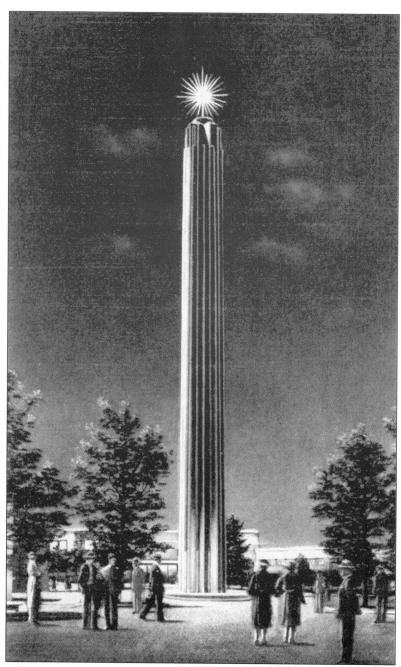

THE STAR PYLON AT NIGHT. Standing 130 feet tall and made of Douglas fir, this pylon symbolized the power of electricity to light the world in an age of global communications. The pylon was placed at the rear entrance of the Communications Building and was one of the impressive attractions witnessed by fairgoers entering through the Long Island Rail Road gate. If you want to catch a glimpse of how this pylon must have looked, visit California's Fresno Tower Theatre. Its soaring staff (also built in 1939) offers a striking resemblance to the fair version. (Image by Interborough News Company; licensed by New York World's Fair; courtesy Lake County, Illinois, Discovery Museum, Curt Teich Postcard Archives.)

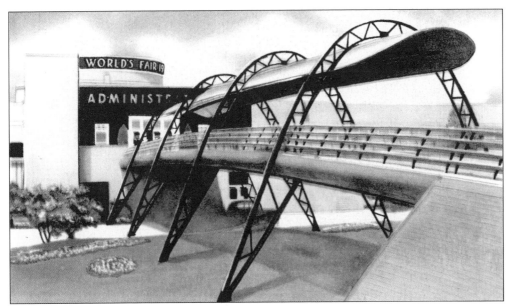

THE BRIDGE OF TOMORROW. Lauded for its architectural ingenuity, the bridge connecting the Administration Building to the Court of Communications employed a design drawn from America's love affair with nautical technology. Created by architects Michael L. Radoslovich and Arthur Barzagli, the bridge had an inverted hull and flowing rivulets of steel, which portrayed a streamlined future of elegance and beauty. (Image created for Exposition Souvenir Corporation by Grinnell Litho Company; licensed by New York World's Fair.)

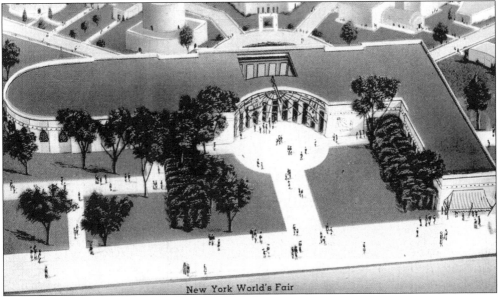

THE BUSINESS SYSTEMS AND INSURANCE BUILDING. This site invited fairgoers to encounter the corporate technologies of tomorrow. Inspired by the towering Trylon and Perisphere, just beyond the building's Rose Court, more than a few visitors stepped inside—if only to catch a glimpse of the huge typewriter there. The architects were Eric Gugler, John B. Slee, and Robert H. Bryson. (Image by Manhattan Post Card Publishing; licensed by New York World's Fair; courtesy of Richard Musante.)

THE ROSE COURT OF THE BUSINESS SYSTEMS AND INSURANCE BUILDING. This view offers a glimpse into the curved entranceway to the court while failing to depict the complexities of the sculptures that were placed in this scene, including the sundial *Time,* featuring figures of sunrise and sunset. (Image created for Exposition Souvenir Corporation by Grinnell Litho Company; licensed by New York World's Fair.)

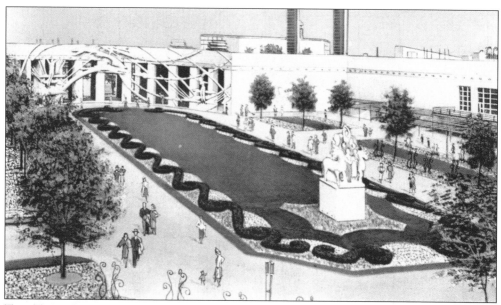

THE TULIP GARDENS IN THE ROSE COURT. Despite occasional grumbles that the World of Tomorrow was too sterile, the 1939–1940 World's Fair was awash in the color of plants—particularly due to the gift from the Netherlands of one million tulips. A gorgeous display of these flowers was planted in the Business and Insurance Building's Rose Court. (Image by Frank E. Cooper; licensed by New York World's Fair; courtesy Lake County, Illinois, Discovery Museum, Curt Teich Postcard Archives.)

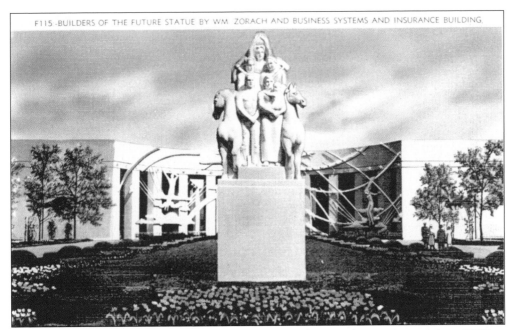

BUILDERS OF THE FUTURE. This piece was created by Lithuanian-born painter-sculptor William Zorach. His sculpture, which stood 18 feet high, featured a boldly optimistic team of workers, builders, and pioneers. (Image by Underwood & Underwood; licensed by New York World's Fair; courtesy of Richard Musante.)

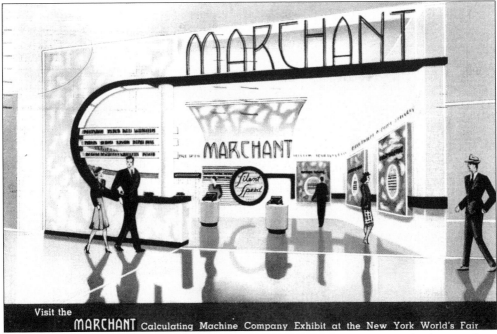

Visit the **MARCHANT** Calculating Machine Company Exhibit at the New York World's Fair

THE MERCHANT CALCULATING MACHINE COMPANY. This image works hard to render a mechanical calculator somehow chic. It accomplishes the task with the aid of smartly dressed fairgoers who appear to prefer another day at the office rather than a visit to an amusement park. (Image by Colourpicture.)

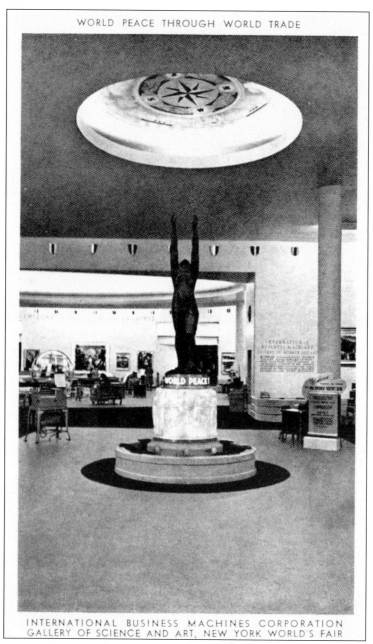

INTERNATIONAL BUSINESS MACHINES CORPORATION
GALLERY OF SCIENCE AND ART, NEW YORK WORLD'S FAIR

THE INTERNATIONAL BUSINESS MACHINES CORPORATION GALLERY OF SCIENCE AND ART.
Ever striving to improve the cultural horizons of its visitors—even those who had reported the
fair to be excessively highbrow—national exhibitors offered dozens of artwork displays
throughout the fair. For example, IBM's Thomas J. Watson called for a 1940 Gallery of Science
and Art (located in the Business and Insurance Building) to feature displays from 53 American
artists. Ostensibly to encourage peace and freedom, the 1940 *Guide Book* offers Watson's far more
bottom-line rationale: "to promote the interest of businessmen in art and of artists in business."
IBM augmented the gallery with its demonstrations of accounting, writing, and grading
machines. (Image by International Business Machines.)

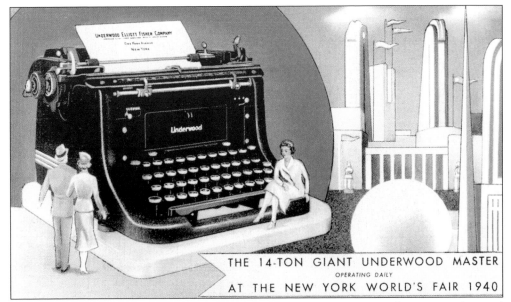

THE 14-TON GIANT UNDERWOOD MASTER
OPERATING DAILY
AT THE NEW YORK WORLD'S FAIR 1940

THE 1940 UNDERWOOD TYPEWRITER. A favorite of world's fairs past, the giant Underwood typewriter impressed visitors of the Communications and Business Systems Zone with its 14-ton demonstration of typing technology that imprinted letters on stationary measuring 9 by 12 feet. Nearby, professional and amateur typists tackled world records while amused crowds gazed at the immensity of it all. (Image by Colourpicture.)

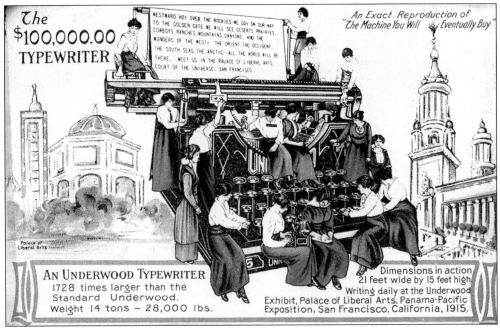

The $100,000.00 TYPEWRITER

WESTWARD HO! OVER THE ROCKIES WE GO! ON OUR WAY TO THE GOLDEN GATE WE WILL SEE DESERTS, PRAIRIES, COWBOYS, RANCHES, MOUNTAINS, CANYONS, AND THE WONDERS OF THE WEST: THE ORIENT, THE OCCIDENT, THE SOUTH SEAS, THE ARCTIC—ALL THE WORLD WILL BE THERE. MEET US IN THE PALACE OF LIBERAL ARTS, COURT OF THE UNIVERSE, SAN FRANCISCO.

An Exact Reproduction of "The Machine You Will Eventually Buy"

Palace of Liberal Arts

AN UNDERWOOD TYPEWRITER
1728 times larger than the Standard Underwood.
Weight 14 tons – 28,000 lbs.

Dimensions in action 21 feet wide by 15 feet high. Writing daily at the Underwood Exhibit, Palace of Liberal Arts, Panama-Pacific Exposition, San Francisco, California, 1915.

THE 1915 UNDERWOOD TYPEWRITER. As a means of comparison, this is the typewriter of tomorrow from the 1915 Panama–Pacific Exposition, held in San Francisco. Offering "an exact reproduction of the machine you will eventually buy," this image demonstrates the kind of corporate optimism that has always pervaded world's fairs. (Author's collection)

THE AMERICAN TELEPHONE & TELEGRAPH BUILDING. The AT&T Building featured exhibits arranged by Henry Dreyfus, most notably the Demonstration Call Room in which visitors were selected by lot to place free long-distance telephone calls anywhere they chose in the United States. The only catch was that exhibit visitors were permitted to listen to the conversations. The architects were Voorhees, Walker, Foley, and Smith. (Licensed by New York World's Fair.)

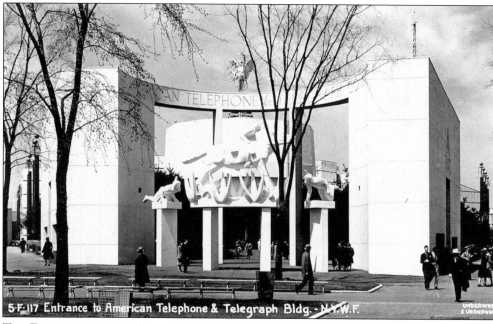

THE ENTRANCE TO THE AMERICAN TELEPHONE & TELEGRAPH BUILDING. Walking past the *Pony Express* sculpture group, visitors encountered a racially charged history lesson about the dangers faced by communications couriers such as this one facing an ambush by American Indians. (Image by Underwood & Underwood; courtesy of Richard Musante.)

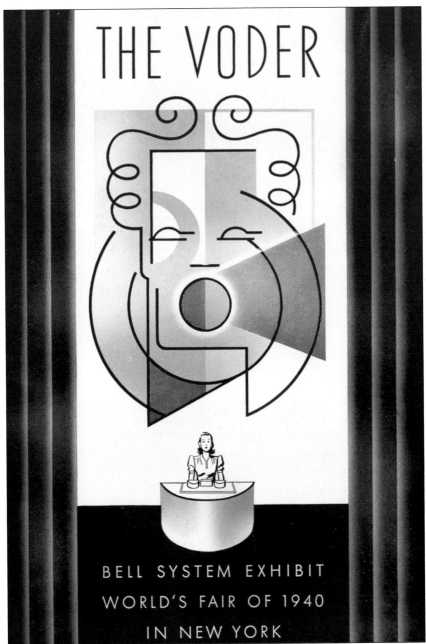

THE VODER

BELL SYSTEM EXHIBIT
WORLD'S FAIR OF 1940
IN NEW YORK

The Voder. One of AT&T's most fascinating exhibits, the Voder demonstrated the potential for an electrical device to simulate the sound of human speech. The pamphlet explains that while Voder stood for voice operation demonstrator, the attraction was also nicknamed "Pedro" after the emperor of Brazil, Dom Pedro, who gasped upon seeing a telephone at the 1876 Philadelphia Exposition: "My God, it talks!" The Voder worked with the aid of an operator, always a female, who manipulated a keyboard and foot pedals connected to electrical circuits and other devices. Responding to random suggestions, the machine operator mimicked human speech through a mixture of modulated hiss and sound vibration. (Author's collection.)

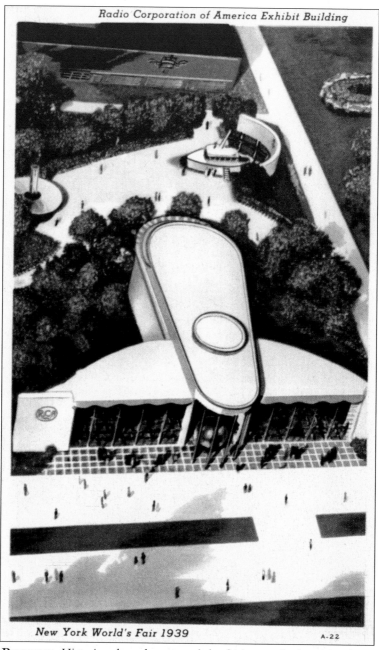

Radio Corporation of America Exhibit Building

New York World's Fair 1939 A-22

THE RCA BUILDING. Historians have long noted the fair's use of mimetic architecture, a style popularized with the advent of the automobile in which buildings resembled what they advertised. This was an era in which motorists heading to the fair passed giant tepees, hamburgers, and even a New Jersey elephant. Thus, the Marine Transportation Hall portrayed two ships and the Aviation Building evoked visions of a vast airport, maybe even a future airplane. So, it was hardly surprising to find that the RCA Building resembled a giant radio tube when viewed from the air. It was designed and built by Skidmore and Owings. (Image created for Exposition Souvenir Corporation by Grinnell Litho Company; licensed by New York World's Fair.)

ANOTHER VIEW OF THE RCA BUILDING. Although television had been shown before—at the 1933–1934 Century of Progress fair in Chicago, for example—it gathered an audience clamoring for the new technology in 1939, and RCA helped fill that need. Beyond the promise of television, RCA also envisioned an age of newspapers delivered by facsimile machine, global wireless communications, and electronic pianos. (Image by Frank E. Cooper; licensed by New York World's Fair; courtesy Lake County, Illinois, Discovery Museum, Curt Teich Postcard Archives.)

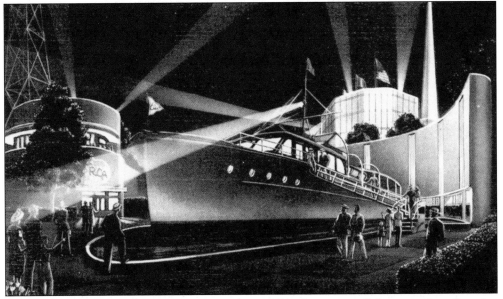

THE RCA BUILDING'S ELCO YACHT. This exhibit demonstrated the necessity of marine communications by showing how modern radio can save ocean craft facing danger on the open seas. (Image by Interborough News Company; licensed by New York World's Fair; courtesy Lake County, Illinois, Discovery Museum, Curt Teich Postcard Archives.)

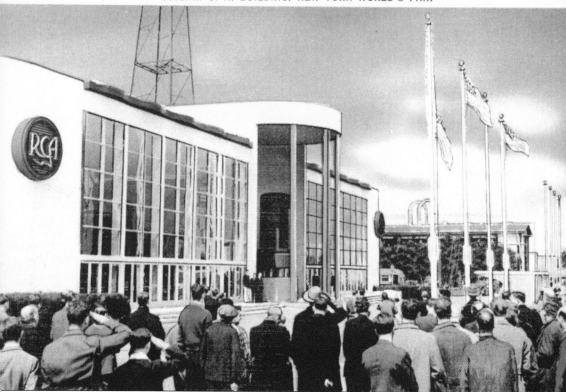

THE RCA BUILDING. Visitors to the RCA exhibit pause to salute the flag. In today's seemingly intractable age of cynicism, this image might be difficult to comprehend. The decade-long Depression just past and the ominous clouds of war ahead, flag-raising and -lowering ceremonies such as this contributed an important ritual to the maintenance of American hope and optimism. Beyond the scientific promises of exhibits such as RCA's, Americans hungered to believe in their country once again. (Image by Manhattan Post Card Publishing; licensed by New York World's Fair; courtesy of Richard Musante.)

Three
SELLING THE PRODUCTS
OF TOMORROW

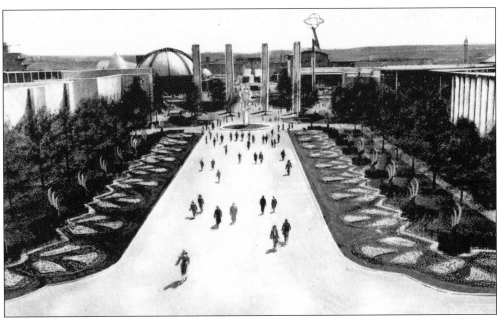

THE PRODUCTION AND DISTRIBUTION ZONE. This view offers a glimpse into the Production and Distribution Zone, dedicated to humankind's transformation of natural resources into goods and services. From this perspective, the U.S. Steel Building is to the left and the stainless steel General Electric lighting bolt is to the right. Directly ahead are the *Four Elements* pylons. From this point, splashes of Consolidated Edison's water ballet could be heard. (Image by Albertype.)

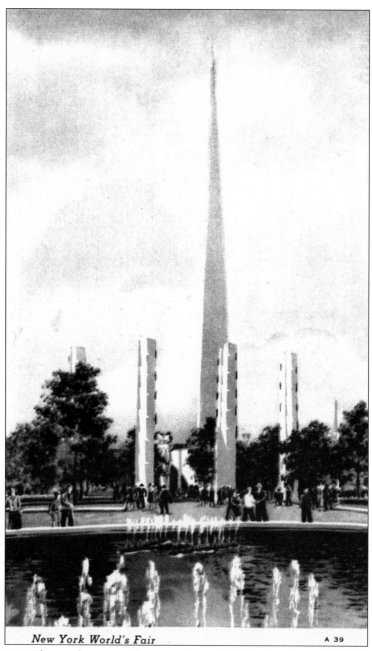

New York World's Fair A 39

FOUR ELEMENTS. These pylons were the centerpiece of the Production and Distribution Zone. Crafted by Carl Paul Jennewein (sometimes misspelled "Jennewsin" on postcards), the elements referred to earth, fire, air, and water. This piece illustrated a common theme of this zone: the basic elemental powers of God were now in the hands of humankind. Affirming this notion, Jennewein chose a simple, potent image, which became a central meeting point. Best known for his popularization of geometrically precise depictions of natural and supernatural images, Jennewein did works that can be seen today at Rockefeller Center, the Brooklyn Public Library, and the Philadelphia Museum of Art. (Image created for Exposition Souvenir Corporation by Grinnell Litho Company; licensed by New York World's Fair.)

THE CONSUMER INTERESTS BUILDING. This site, created by architects Frederic C. Hirons and Peter Copeland, displayed new forms of power production. The following season, the building shifted to an entirely new form of "power" by emphasizing the fashion world. The 1940 *Guide Book* demonstrates its acutely nationalistic fervor by announcing, "The United States can be independent of foreign fashion influence whenever it wishes, and it wishes now." (Image created for Exposition Souvenir Corporation by Grinnell Litho Company; licensed by New York World's Fair.)

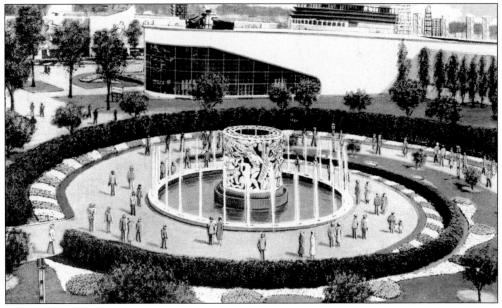

THE SPIRAL HEDGE AND TULIP BEDS, PERYLON CIRCLE. Anchored by Malvina Hoffman's *Dances of the Races* sculptured fountain, this site lies between the New York City Building and the Hall of Pharmacy, with its 15- by 20-foot medicine chest. (Image by Frank E. Cooper; licensed by New York World's Fair; courtesy Lake County, Illinois, Discovery Museum, Curt Teich Postcard Archives.)

A *NATIONAL GEOGRAPHIC* ADVERTISEMENT FOR EASTMAN KODAK, JULY 1939. Even before fairgoers entered the Kodak building, with its product displays, photo spots, and slide shows on the "world's largest screen," they encountered advertising images such as this one for the Ciné-Kodak movie camera: "Think of being able to get the complete record with your movie camera. Think of taking it back home to show your friends—living it over again, time after time, with all its thrilling fun." (Author's collection.)

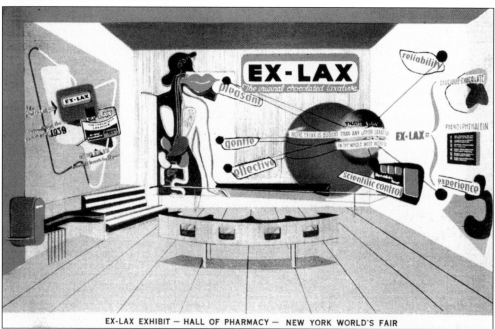

THE EX-LAX EXHIBIT IN THE HALL OF PHARMACY. Lest one forget the corporate purpose of the World's Fair, behold the Ex-Lax exhibit that was designed by Oskar Stonorov under strict orders to impose a dignified theme upon this giggle-inducing component of the Hall of Pharmacy. Elsewhere in the hall, visitors once again confronted the theme of technological enthusiasm inspired by the fair as they encountered a drugstore of tomorrow and a soda fountain of the future. (Image by Colourpicture.)

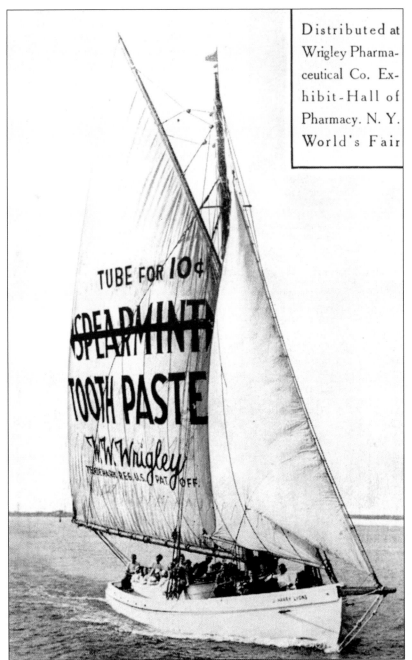

A WrigleyAdvertisement.**Thecacophonyofadvertisingimagesthatdefinesomuchofthe built environmentisnotjustaproblemoftoday,asevidencedbythispostcard.Wrigley Pharmaceutical handed out chewing gum from its exhibit in the Pharmacy Building and also mailed samples home as souvenirs, according to David Gelernter's *1939: The Lost World of the Fair*. Wrigley pasted its logo wherever it could, including Times Square, where it had a block-long spearman advertisement featuring multihued fish composed of more than 35,000 light bulbs, according to an April 15, 1939, *Saturday Evening Post* article. No doubt Wrigley sold plenty of gum in 1939. (Image created by Loughead & Company.)

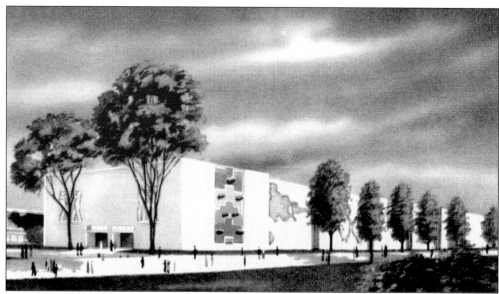

THE HALL OF INDUSTRY AND METALS. Created by architects William Gehron, Benjamin W. Morris, and Robert B. O'Conner, the Metals Building demonstrated steel manufacturing processes, compared modern gearless elevators to their stream-driven predecessors, and presented a mural of San Francisco's new Golden Gate Bridge. By the 1940 season, the Hall of Metals was renamed the Hall of Industry and Metals Building. (Image created for Exposition Souvenir Corporation by Grinnell Litho Company; licensed by New York World's Fair.)

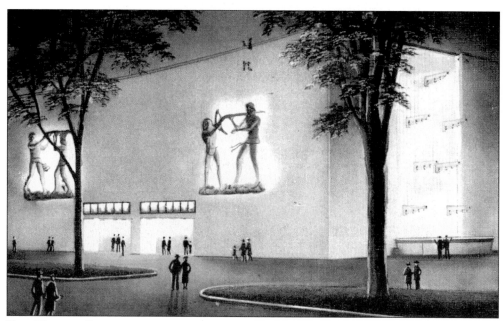

THE HALL OF INDUSTRY AND METALS AT NIGHT. This view depicts two relief sculptures by Carl L. Schmitz: *Prometheus and Man* and *Vulcan and Man*. Both illustrate how humankind had employed the power of the gods—the fire and the forge—to build the civilization of today and the world of tomorrow. (Image by Manhattan Post Card Publishing; licensed by New York World's Fair.)

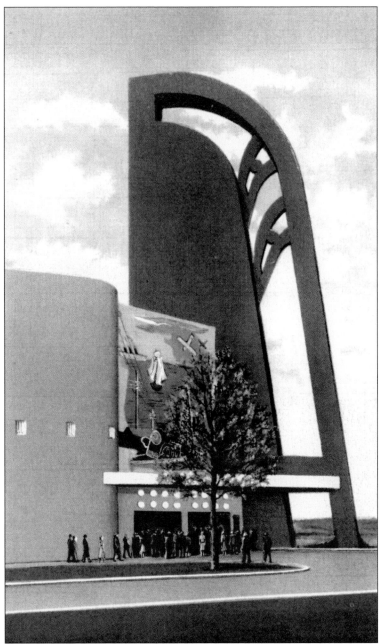

THE ELECTRICAL PRODUCTS BUILDING MURAL. The walls of many 1930s-era post offices had (and still have) murals depicting the values of Depression-era America in the formally geometrical style of the day. The fair, of course, had murals almost everywhere, competing with sculptures to catch the eyes of wandering visitors. Some had classical motifs and intricate symbolism; other more accessible ones, such as this example, elegantly displayed the power of human technology to reshape the world. *Distribution,* created by Martha Axley, conveys modern distribution as locomotives, ships, aircraft, and electricity. In 1939–1940, technology was naturally a good thing. (Image by Frank E. Cooper; licensed by New York World's Fair; courtesy Lake County, Illinois, Discovery Museum, Curt Teich Postcard Archives.)

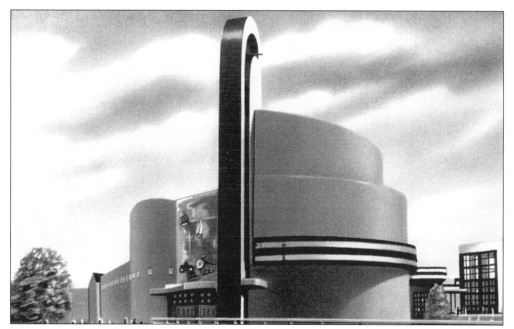

THE ELECTRICAL PRODUCTS BUILDING. This structure, created by architects A. Stewart Walker and Leon N. Gillette, offered one of the most striking features of the fair. With its impressive 100-foot-tall blue pylon, the building invited visitors to encounter a gleaming future of Sunbeam mixers, Remington Rand shavers, and electric sewing machines. In 1940, the site was transformed into the Power (Electrical and Steam) Building. (Image created for Exposition Souvenir Corporation by Grinnell Litho Company; licensed by New York World's Fair.)

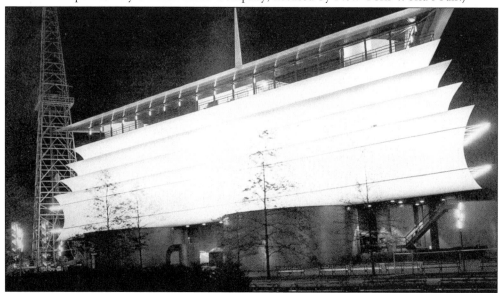

THE PETROLEUM INDUSTRY EXHIBIT. At this exhibit, oil workers bored for black gold under the fairgrounds. Resting upon four oil tanks and sporting a working oil derrick, the Petroleum Building was designed by Gilbert Rohde and built by Woorhees, Walker, Foley & Smith. At night, it glowed blue. (Image from *See the New York Worlds Fair . . . in Pictures*; © Rogers-Kellogg-Stillson.)

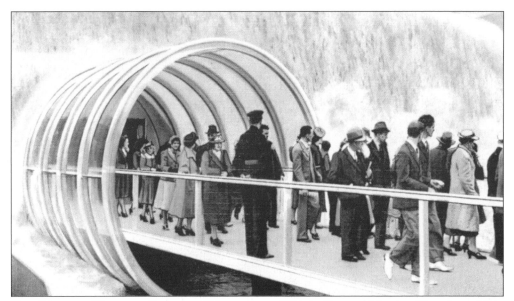

THE ELECTRIC UTILITIES BUILDING WATERFALL. With its Forward March of America exhibit, this building gathered some 175 electricity producers to offer sharp contrast between the gaslit days of 1892 and the brighter world to come. It was created by architects Wallace K. Harrison & Andre Fouilhoux. Passing a 150-foot transmission tower, visitors walked through a glass tunnel that protected them from a splashing waterfall. (Image by Manhattan Post Card Publishing; licensed by New York World's Fair.)

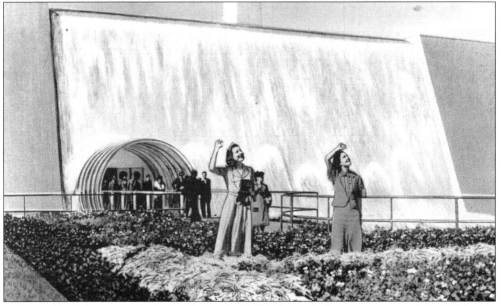

VISITORS TO THE WATERFALL. The author of this postcard prose seems to have felt pretty inspired that day: "Ah, there skipper! The personable young things amid the shrubbery are waving to an aviator friend passing low over the World's Fair . . . Visitors leaving the structure are delighted to find themselves passing through a miniature Niagara without becoming damp." (Image by Frank E. Cooper; licensed by New York World's Fair; courtesy Lake County, Illinois, Discovery Museum, Curt Teich Postcard Archives.)

An electrical view of our "World of Today"

● It now costs the average American household only $1.71 to light its house or apartment by electricity for a month (using 40 kilowatt hours). If this home had to use candles, it would have to pay $346.65 a month for an equivalent amount of light... would have to burn 5,778 candles, totaling over a half ton in weight.

$346⁶⁵

$1⁷¹

"AN ELECTRICAL VIEW OF OUR WORLD OF TODAY." Perhaps it was simply a coincidence that Commonwealth & Southern Corporation chose to employ a strategically placed candle and oddly spherical light bulb in its advertisement that appeared in *Forbes Magazine* on June 15, 1939. However, it seems probable that this appeal for governmental deregulation of the nation's power supply was seeking inspiration from the World of Tomorrow in contesting the policies of its day. (Author's collection.)

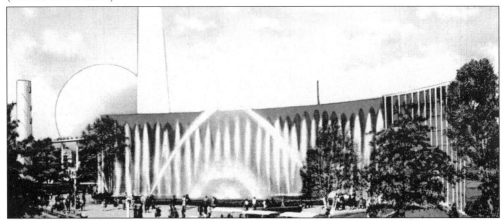

THE CONSOLIDATED EDISON BUILDING. The curved surface of this building featured a 9,000-square-foot wall onto which 40,000 gallons of water were pumped an hour. Aided by its painted background and special lighting, the surface glowed blue at night. Inside, fairgoers learned about the electrical future promised by Consolidated Edison. The building was created by architects Wallace K. Harrison & Andre Fouilhoux. (Image by Frank E. Cooper; licensed by New York World's Fair; courtesy Lake County, Illinois, Discovery Museum, Curt Teich Postcard Archives.)

CONSOLIDATED EDISON'S *CITY OF LIGHT* AT DAWN. One of the most arresting attractions at the fair, Walter Dorwin Teague's *City of Light* diorama was located within the Consolidated Edison Building. It portrayed New York City from Westchester to Coney Island, along with an endless motion of subways and elevators. Stretching a city block and rising three stories high, it demonstrated the power of electricity in urban life. (Author's collection.)

CONSOLIDATED EDISON'S *CITY OF LIGHT* AT NIGHT. This vast display of New York City was so popular, attracting an estimated 7.5 million visitors in 1939, that its designers added more effects for the 1940 season. Now, along with its 4,000 buildings and 12-minute depiction of 24-hour city life, viewers enjoyed the spectacle of a lightning storm. Power to the city is threatened, but Consolidated Edison's reserves kick in just in time. (Author's collection.)

THE MEN'S APPAREL QUALITY GUILD EXHIBIT BUILDING. Oddly included in the Production and Distribution Zone, this site tried to convince suspicious fellows that their dignity would not be challenged by entering a fashion exhibit. Designed by George W. McLaughlin and built by architects Starrett & Van Vleck, the structure offered sporting exhibits and even promised that heavyweight champion Jack Dempsey would drop by from time to time. (Created for Exposition Souvenir Corporation by Grinnell Litho Company; licensed by New York World's Fair.)

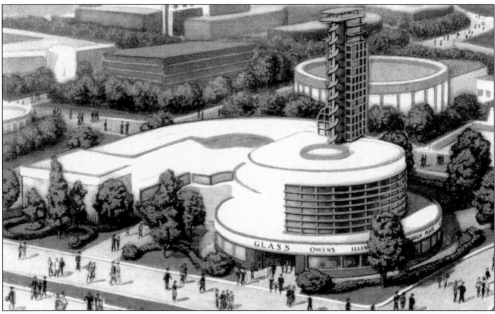

THE GLASS CENTER BUILDING. With its blue plate glass and glass block tower streaking 108 feet into the sky with neon, the Glass Center provided a photographer's dream. Inside, exhibitors made a compelling argument that glass represented the height of human civilization. The center was designed and built by Shreve, Lamb & Harmon. (Image by Manhattan Post Card Publishing; licensed by New York World's Fair.)

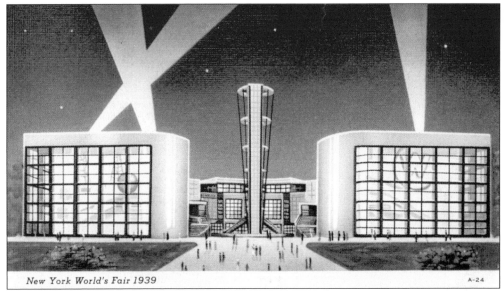

New York World's Fair 1939 A-24

THE WESTINGHOUSE BUILDING. Created by architects Skidmore and Owings and John Moss, this horseshoe-shaped building contained two main exhibits dedicated to electrical power and electrical living. In both, Westinghouse inspired a million domestic fantasies of better living through electricity with its depictions of futuristic timesaving devices. (Image created for Exposition Souvenir Corporation by Grinnell Litho Company; licensed by New York World's Fair.)

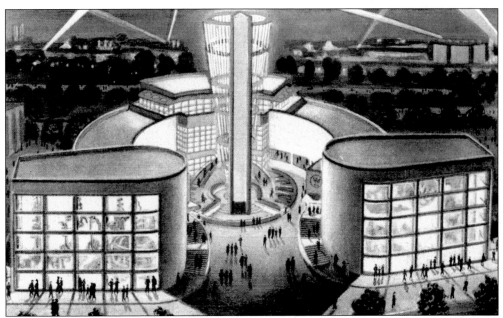

AN OVERHEAD VIEW OF THE WESTINGHOUSE BUILDING. Although Westinghouse promised a brighter future in just a few more years, the company bet on a far more distant future when it built a time capsule meant to be unearthed 5,000 years hence. Just in case, Westinghouse sponsored the distribution of more than 3,000 *Books of Record* to libraries, universities, and monasteries worldwide in hopes that the capsule might be discovered in the year 6939. (Image by Manhattan Post Card Publishing; licensed by New York World's Fair.)

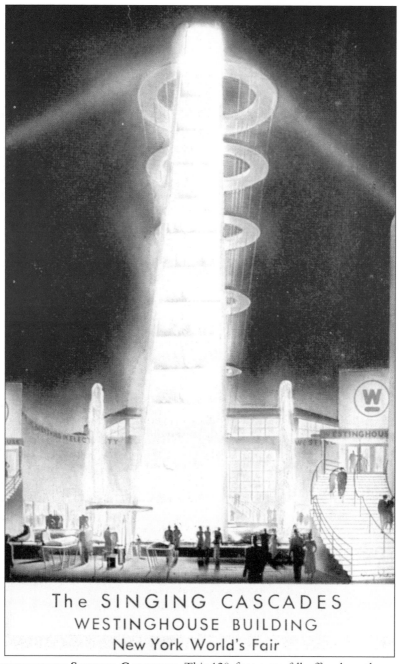

The SINGING CASCADES
WESTINGHOUSE BUILDING
New York World's Fair

THE WESTINGHOUSE SINGING CASCADES. This 120-foot waterfall offered another example of the fair's numerous fusions of color, music, and liquid power. The Singing Cascades showed the fair's modern aesthetic just as powerfully as did the more commonly cited Trylon and Perisphere. Six tons of water poured down the exhibit's 15 cascades, inviting viewers to contemplate an optimistic but troubling vision of the future. Although humankind may still have been the "measure of all things," exhibits such as the Singing Cascades began to celebrate the tools of humanity even more than the toolmakers, imbuing the straight line and neon light with an artistic reverence that might have been found earlier in nature. (Image by Lumitone Photoprint.)

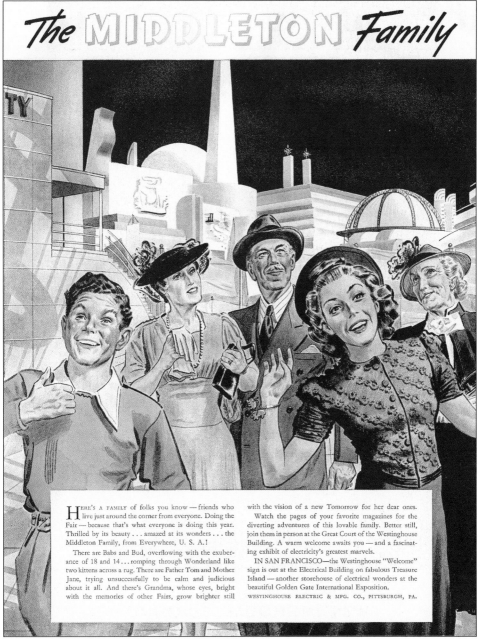

The MIDDLETON Family

HERE's A FAMILY of folks you know — friends who live just around the corner from everyone. Doing the Fair — because that's what everyone is doing this year. Thrilled by its beauty . . . amazed at its wonders . . . the Middleton Family, from Everywhere, U. S. A.!

There are Babs and Bud, overflowing with the exuberance of 18 and 14 . . . romping through Wonderland like two kittens across a rug. There are Father Tom and Mother Jane, trying unsuccessfully to be calm and judicious about it all. And there's Grandma, whose eyes, bright with the memories of other Fairs, grow brighter still with the vision of a new Tomorrow for her dear ones.

Watch the pages of your favorite magazines for the diverting adventures of this lovable family. Better still, join them in person at the Great Court of the Westinghouse Building. A warm welcome awaits you — and a fascinating exhibit of electricity's greatest marvels.

IN SAN FRANCISCO—the Westinghouse "Welcome" sign is out at the Electrical Building on fabulous Treasure Island — another storehouse of electrical wonders at the beautiful Golden Gate International Exposition.

WESTINGHOUSE ELECTRIC & MFG. CO., PITTSBURGH, PA.

THE MIDDLETON FAMILY. The Westinghouse exhibit introduced America to the Middletons, an ersatz Indiana family who viewed the fair with awe and enthusiasm. During their advertisement-visits, Babs, Bud, and the other Middletons witnessed Electro the Moto-Man, the dishwasher Battle of the Centuries, and a television show. Westinghouse also commissioned a film directed by Robert S. Snody in which the Middletons faced an ideologically charged love triangle. In the film, Babs faced a choice between two beaus: Nicholas Makaroff, her Marxist art teacher, and Jim Treadway, her hometown friend who also worked for Westinghouse. Throughout, Westinghouse depicted these characters in a not-too-subtle contest between Soviet-style planning and corporate capitalism. Guess who won?

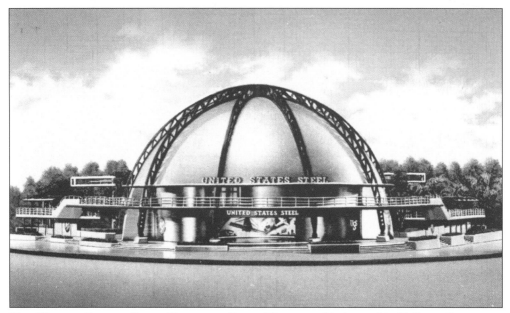

THE UNITED STATES STEEL BUILDING. Resembling a steel helmet, this 66-foot-tall structure reflected the sun brightly from its inside-out silver-blue surface. Inside, fairgoers learned about modern steel manufacturing processes and saw once more how steel, beyond all other products, ensured a brighter tomorrow. The exhibit and building were designed by Walter Dorwin Teague and built by architects York & Sawyer. (Image by the Union News; licensed by New York World's Fair; courtesy Lake County, Illinois, Discovery Museum, Curt Teich Postcard Archives.)

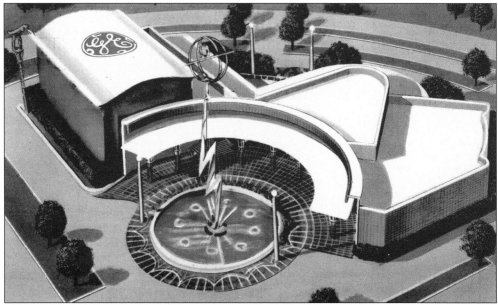

THE GENERAL ELECTRIC BUILDING. At the General Electric exhibit, millions of volts crackled through the air, radio waves popped popcorn, magic kitchens sang to themselves, and visitors queued to catch a glimpse of a 3,000-year-old mummy. The architects were Voorhees, Walker, Foley, and Smith. (Image by Interborough News; licensed by New York World's Fair; courtesy Lake County, Illinois, Discovery Museum, Curt Teich Postcard Archives.)

A Closeup of the Du Pont Exhibit. With its 105-foot Tower of Chemistry, Du Pont made a valiant effort to convey the complex tools used by chemists to unleash natural forces for human purposes. Surrounding the tower, a 70-foot-tall sheath sought to evoke the chemical plants in which tomorrow's products were to be born. (Image created for Exposition Souvenir Corporation by Grinnell Litho Company; licensed by New York World's Fair.)

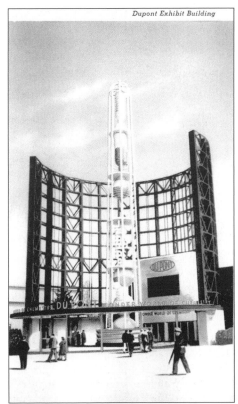

Dupont Exhibit Building

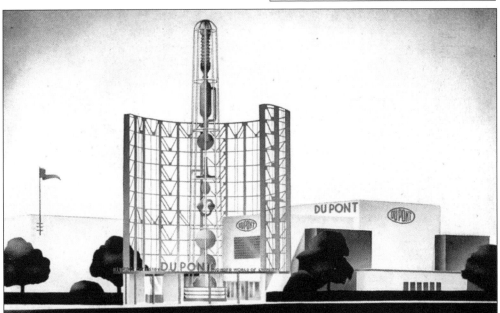

The Du Pont Exhibit. Advertising "Better Things for Better Living—Through Chemistry," the Du Pont building featured rayon yarn, cellophane, and futuristic stockings made from nylon, "the spectacular new chemical product made basically from coal, air and water." The building was designed by Walter Dorwin Teague, R. J. Harper, and A. M. Erickson. (Author's collection).

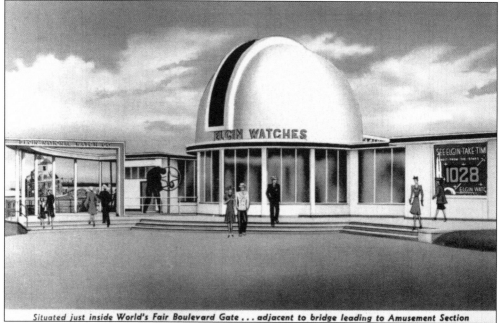

Situated just inside World's Fair Boulevard Gate ... adjacent to bridge leading to Amusement Section

THE ELGIN WATCH BUILDING. Boasting a planetarium to demonstrate the role of stars in timekeeping, Elgin also produced a postcard designed to *save* time. Courteously summarizing visitors' experiences, the card provided the following prose: "I've just heard how time is taken from the stars. It's exciting. Take my advice and make the Elgin Watch building the starting point for all your World's Fair sightseeing. It's so conveniently located." (Courtesy Lake County, Illinois, Discovery Museum, Curt Teich Postcard Archives.)

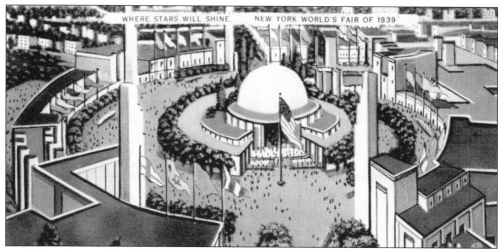

THE PLANETARIUM. This 1938 postcard predated much of the final planning for the fair and, thus, can be confusing. After all, no guidebooks report the existence of a freestanding planetarium in the Production and Distribution Zone. The image is based on a photograph; there was *something* there. Eventually the building begins to look familiar, reminding the viewer of the Elgin Watch Building where, yes, a small planetarium delighted fairgoers. (Image by Miller Art based on a photograph by Keystone.)

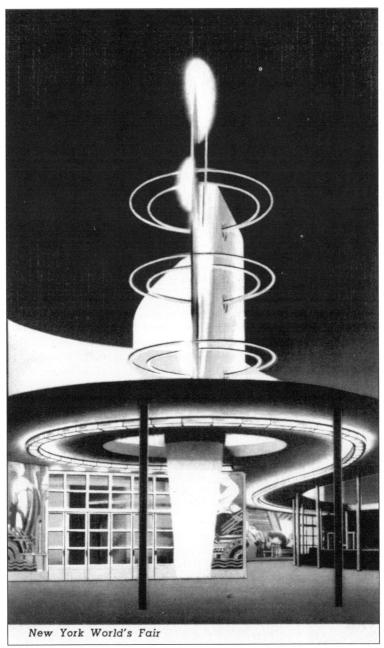

New York World's Fair

THE FAIR OPERATIONS BUILDING. Given its role in fair operations, one might imagine that this building was located near the Administration Building behind the Communication Zone. However, it was not. Researching the murals, one discovers a clue from artist Herman Van Cott, whose depictions of *Distribution* graced a small building in the Production and Distribution Zone. This building, located behind the General Electric Building adjacent to the Grand Central Parkway, is often unnamed on fair maps or left as a blank spot. However, one may fairly speculate that the mystery site was indeed the Fair Operations Building. (Image by Interborough News Company; licensed by New York World's Fair; courtesy Lake County, Illinois, Discovery Museum, Curt Teich Postcard Archives, and Richard Musante.)

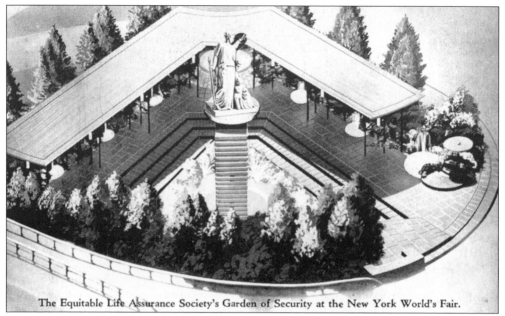

The Equitable Life Assurance Society's Garden of Security at the New York World's Fair.

EQUITABLE LIFE ASSURANCE SOCIETY'S GARDEN OF SECURITY. Next to the Empire State Bridge, leading to the Amphitheatre, this resting spot included a replica of John Quincy Adams Ward's *The Goddess of Protection,* featuring a female Greek warrior standing guard over a mother and orphan. (Author's collection.)

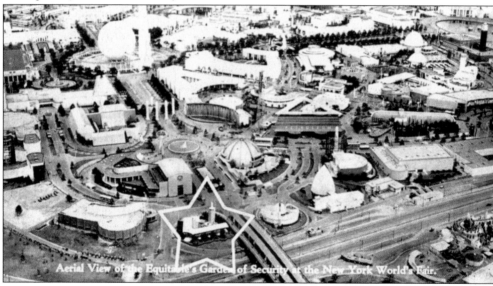

Aerial View of the Equitable's Garden of Security at the New York World's Fair.

AN OVERHEAD VIEW OF THE EQUITABLE LIFE ASSURANCE SOCIETY. An explosion of postcards for the fair produced many bird's-eye views of the 1,216-acre site. Looking away from the Production and Distribution Zone, this image relates the Equitable Pavilion to the larger concentration of structures that celebrated American industry. Opposite from this pavilion, across from the Empire State Bridge, sits the Elgin Watch Building. Behind both sites, toward the Trylon and Perisphere, are the General Electric Building and the United States Steel Building, on the left and right of the Plaza of Light respectively. Farther along, toward the *Four Elements,* are the Electrical Utilities Building and the Consolidated Edison Building. (Author's collection.)

THE HOME FURNISHINGS BUILDING. Created by architect Dwight James Baum, this building housed the focal exhibits of the Community Interests Zone. Inside, visitors encountered a high-minded presentation that, with directed lights and an evocative narrative, was designed to convey the improvements enjoyed by Americans since 1789. Demonstrating the shift in our lives from drudgery to leisure, the exhibit introduces the real point of the Community Interests Zone: to sell products including Fuller brushes, Hoover cleaners, and Wilbert "No-Rub" cleaners. By 1940, the Home Furnishings Building was transformed into America at Home, in which the consumer vision was made even more transparent. (Image by Manhattan Post Card Publishing; licensed by New York World's Fair.)

MODEL HOMES IN THE TOWN OF TOMORROW. The Town of Tomorrow offered a showcase of 15 suburban homes of the type found near the Atlantic coast. Ranging in cost from $3,000 for a four-room economy home to $35,000 for a 10-room high-end model, the demonstration homes incorporated multipurpose design and modern uses of electricity and insulation. In 1940, planners added two houses nearby on Rainbow Avenue to serve as temporary homes for 48 typical American families who traveled and stayed at the fair, all expenses paid, for a week at a time. (Image by Frank E. Cooper; licensed by New York World's Fair; courtesy Lake County, Illinois, Discovery Museum, Curt Teich Postcard Archives.)

THE CONTEMPORARY ARTS BUILDING. Envisioned as a democratic display spot for American artists of all recognized schools, including the potentially unnerving modern school, this building presented some 800 works selected by committees. Initially, the curators charged admission. However, by 1940 they waived the fee in hopes that underwhelmed patrons would enter the newly named American Art Today exhibit. The architects were Frederick L. Ackerman, Joshua D. Lowenfish, and John V. Van Pelt. (American Art Publishing; licensed by New York World's Fair.)

THE HALL OF FASHION. During the 1939 season, the fair depicted women's and children's fashions. The men's fashion building was located in the more manly Production and Distribution Zone. By 1940, many of the displays were moved to the former Consumers Building. The Hall of Fashion was then occupied by Piccadilly Restaurant and dedicated to special events. The architects for the building were Frederick G. Frost Sr., Frederick G. Frost Jr., and Ward W. Fenner. (Created for Exposition Souvenir Corporation by Grinnell Litho Company; licensed by New York World's Fair.)

THE COSMETICS BUILDING. Even before Maison Coty signed on, fair planners were gearing for an attention-grabbing site with this building, with its ziggurat terrace tower roughly resembling a perfume box or the cap of a perfume bottle. The building was designed by Donald Deskey and built by architects John Walker Cross, Eliot Cross, and John Hironimus. (Created for Exposition Souvenir Corporation by Grinnell Litho Company; licensed by New York World's Fair.)

THE MAISON COTY BUILDING. This later image demonstrates a subtle change to the building's perfume box crown. Inside, the Hall of Perfumes (clearly before the age of olfactory correctness) sought to attract its ideal demographic. Prose from the 1940 *Guide Book* practically slinks with promises of an experience that would be "exciting and feminine," "seductively lit," and "infinitely alluring." (Image by Manhattan Post Card Publishing; licensed by New York World's Fair.)

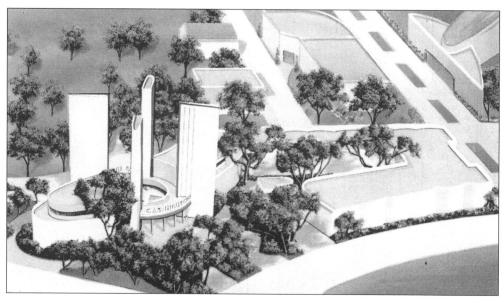

THE GAS EXHIBITS BUILDING. The 1939 season's gas exhibit promised sober displays of an all-gas home, "modern but not modernistic," that would enable fairgoers to "thrill at the contributions of science to daily living." By 1940, visitors entered a Gas Wonderland, with mystery gardens, disappearing dwarfs, flaming cactus plants, and Tiny Town with talking houses. The building was created by architects Skidmore & Owings, and John Moss. (Image by Frank E. Cooper; created for Exposition Souvenir Corporation by Grinnell Litho Company; licensed by New York World's Fair.)

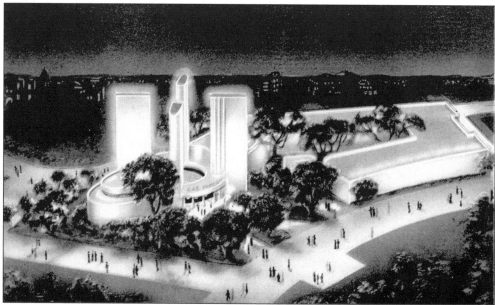

THE GAS EXHIBITS BUILDING AT NIGHT. Gas utility and products exhibitors from the United States and Canada were placed in this striking building, a showcase of elegant design. Four 90-foot pylons marked the corners of the Court of Flame, with its perpetual luminescence burning blue and yellow at night. (Created for Exposition Souvenir Corporation by Grinnell Litho Company; licensed by New York World's Fair.)

THE MEDICINE AND PUBLIC HEALTH, SCIENCE AND EDUCATION BUILDINGS. Easily one of the most eye-popping sites of the fair, this attraction emphasized the miraculous nature of human existence with the aid of talking skeletons, X-ray machines, and a 22-foot-tall figure of a man whose animated heartbeat greeted fairgoers with a pounding thump. The buildings were designed by architects Mayers, Murray, and Phillip. (Created for Exposition Souvenir Corporation by Grinnell Litho Company; licensed by New York World's Fair. Courtesy of Richard Musante.)

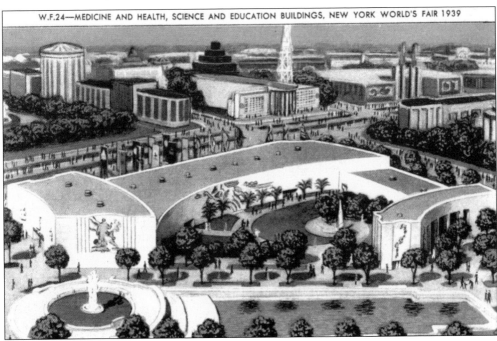

W.F.24—MEDICINE AND HEALTH, SCIENCE AND EDUCATION BUILDINGS, NEW YORK WORLD'S FAIR 1939

ANOTHER VIEW OF THE MEDICINE AND PUBLIC HEALTH, SCIENCE AND EDUCATION BUILDINGS. The Transparent Man exhibit displayed actual human organs and a set of embryos to demonstrate the science of heredity. Throughout, the site celebrated St. Augustine's belief that, more than any other mystery of nature, "Man himself is the most wonderful." (Image by Manhattan Post Card Publishing; licensed by New York World's Fair.)

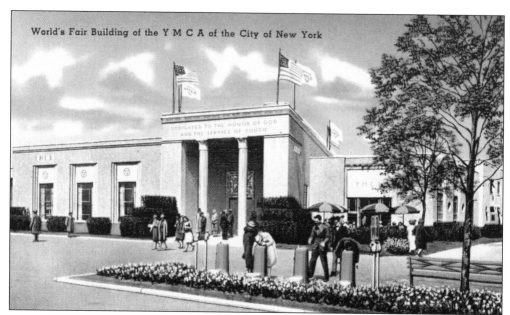

THE YMCA BUILDING. Emphasizing that both women and men were invited, the YMCA Building depicted a large map designating locations of its facilities around the world. Created by architect Dwight James Baum, the building offered a comfortable rest stop for people who wished to write a letter. In the foreground, fairgoers stop for a sip from that most democratic of institutions, the public water fountain. (Tichnor Quality Views.)

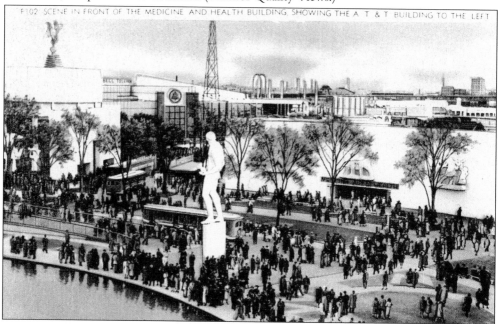

ASTRONOMER. Carl Milles's statue was often photographed with the Perisphere in the background (imagine it located behind this scene to the left). However, such a perspective almost inevitably overshadows its subject. In contrast, this view portrays the inspiring figure of human ingenuity as it towers over the buses and crowds of people near the Medicine and Public Health Building. (Image by Manhattan Post Card Publishing; licensed by New York World's Fair.)

106

Four

ENTERTAINMENT AND
EATS IN THE
WORLD OF TOMORROW

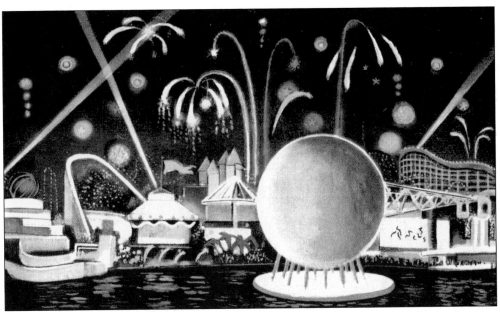

THE AMUSEMENT AREA. Like its predecessors, the 1939–1940 fair sought to balance education with entertainment—this time, on a loop rather than a midway. Of course, the 280-acre Amusement Zone also demonstrated the racial politics of the day, as the 1939 *Fair Guide* intones: "Here are strange people from remote lands which you have read about . . . strange black beings with enormous distended lips; headhunters, too." (Image by Manhattan Post Card Publishing; licensed by New York World's Fair.)

THE CHILDREN'S WORLD. So much has been written about the lofty ideology of the fair that one might forget that children were ever invited to Flushing Meadows. However, in 1939, exhibitors such as R. H. Macy and Gimbel Brothers hosted a Children's World within the Amusement Zone. Here, children could take a Trip around the World. According to the 1939 *Guide Book*, they "may take the usual side trips, sailing in small boats on the waterways of Holland and on the Italian Lakes, or travel by burro to the crater of an active Hawaiian volcano and through an Indian Village on a Mexican mesa." Children's World also offered childcare for parents seeking the more adult pleasures of the fair. (Author's collection.)

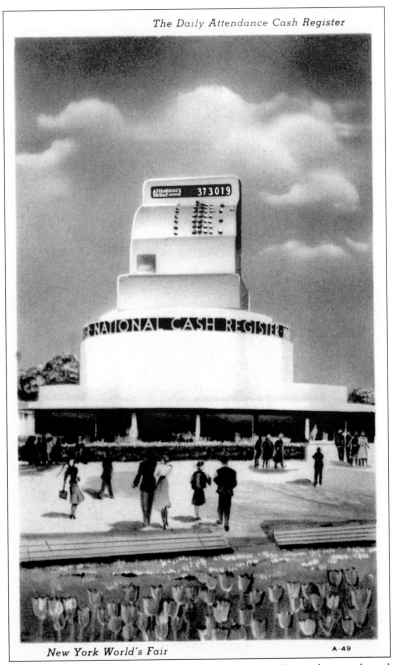

ATTENDANCE TODAY 373019

NATIONAL CASH REGISTER

New York World's Fair A-49

THE NATIONAL CASH REGISTER. Another of Walter Dorwin Teague's marvelous designs, this giant revolving attraction displayed the fair's daily attendance with numbers that were updated every 10 minutes. The entire display stood some 74 feet high. It was another example of mimetic architecture. However, that was part of the problem. Initially, the firm that created this exhibit envisioned its inclusion in the main part of the fair, but the cash register's inability to conform to fair restrictions resulted in its banishment to the Amusement Zone. (Created for Exposition Souvenir Corporation by Grinnell Litho Company; licensed by New York World's Fair.)

109

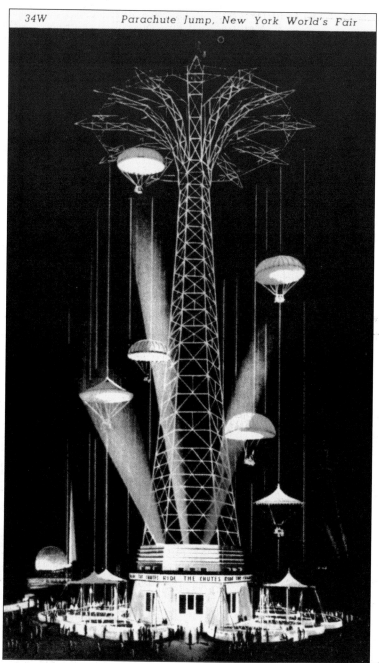

THE PARACHUTE JUMP. This Amusement Zone exhibit rose 250 feet skyward, promising happy landings to fairgoers willing to tackle its lofty height. Surviving films from the fair show gleeful folks ascending slowly to the apex and then dropping. The films also contain the shrieks induced by this plunge. Sponsored by Lifesavers, the Parachute Jump proved to be popular despite occasional technical glitches that sometimes left parachutists aloft for hours. Unlike most other fair exhibits, the Parachute Jump lived on for decades as an attraction at Coney Island. (Image by Frank E. Cooper; created for Exposition Souvenir Corporation by Grinnell Litho Company; licensed by New York World's Fair.)

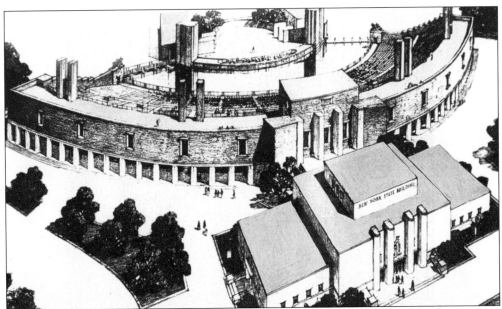

THE AMPHITHEATRE AND NEW YORK STATE BUILDING. The Fountain Lake (renamed Liberty Lake in 1940) Amphitheatre boasted one of the most popular attractions at the fair, Billy Rose's Aquacade. Because the stage was set 60 feet out on the water, Rose could wow audiences with spectacles like his *Rainbow Curtain*. In the foreground, the New York State Building featured a relief map of the empire state. (Image from *See the New York Worlds Fair . . . in Pictures*; © Rogers-Kellogg-Stillson.)

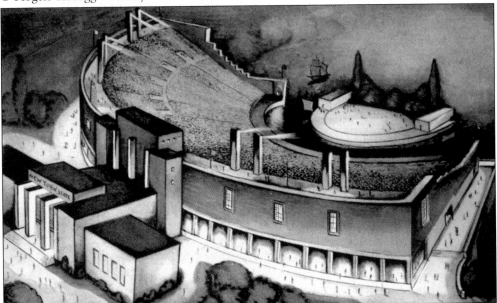

THE NEW YORK STATE AMPHITHEATRE. Featuring stars such as Johnny Weissmuller, Buster Crabbe, and Eleanor Holm, Billy Rose's Aquacade offered an illusion of Niagara Falls, which with the aid of colorful lights and powerful pumps cascaded 8,000 gallons of water per minute. (Image created for Exposition Souvenir Corporation by Grinnell Litho Company; licensed by New York World's Fair.)

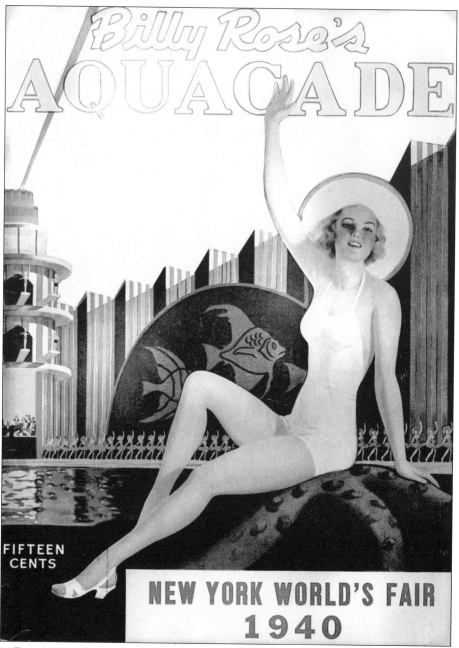

BILLY ROSE'S AQUACADE. This extravaganza represented Billy Rose's attempt to bring the glitz and razzmatazz of pricey Broadway revues to the eyes of average folks. The public certainly showed up. Featuring high divers, synchronized swimmers, and towering water effects, the Aquacade drew five million guests in 1939. In the 1940 version, Rose's aquagals and aquadudes performed scenes reminiscent of previous world's fairs before concluding with a patriotic tribute to Yankee Doodle. A famed showman, Rose was also a prolific lyricist. Among his many hits were "Me and My Shadow," "I Found a Million Dollar Baby (in a Five and Ten Cent Store)," and "It's Only a Paper Moon." He was inducted into the Songwriter's Hall of Fame in 1970. (Author's collection.)

A *DIAMOND HORSESHOE* ADVERTISEMENT. Along with his watery spectaculars, Billy Rose was a nightclub and theater owner. This advertisement for one of Rose's New York properties, the Diamond Horseshoe, appeared in the Aquacade booklet. The popular club was praised by no less a social commentator than Walter Winchell: "The girls are dreams, and the costumes saucier than a can-can petticoat." Movie buffs may recognize the name of the club because it appeared in a 1945 film entitled *Billy Rose's Diamond Horseshoe* (the most commonly viewed version of the film omits Rose's name). Starring Betty Grable, Dick Haymes, and Phil Silvers, the musical offered relief (and an appeal for war bonds) to Americans who had grown weary from years of conflict overseas. (Author's collection.)

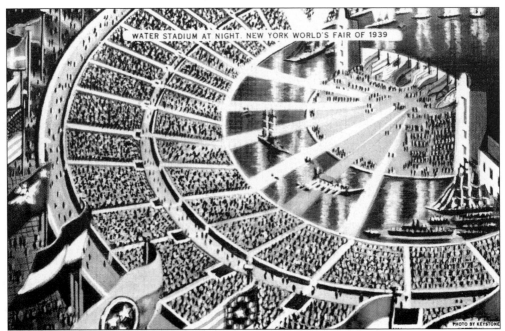

PHOTO BY KEYSTONE

THE WATER STADIUM AT NIGHT. Planned as one of the permanent exhibits of the fair, the Amphitheatre (home of the famed Aquacade) offered an impressive focal point to the Amusement Zone. After the fair, the Amphitheatre was renamed after longtime Queens resident Gertrude Ederle, the first woman to successfully swim the English Channel. Sadly, the site fell into disrepair and it was razed in 1997. (Image published by Tichnor Quality Views, based on a photograph by Keystone.)

THE MUSIC HALL. The 2,500-seat egg-shaped Music Hall, created by architects Reinhard & Hofmeister, was renowned for its nearly flawless acoustics and curved facade. Located on the fair's version of Times Square, it promised a cultural exhibition to counteract the rowdier exhibits of the Amusement Zone such as the Live Monsters reptile display, the bare-breasted Living Magazine Covers, and the supposedly anthropological display of "savage" races called Strange as It Seems. (Created for Exposition Souvenir Corporation by Grinnell Litho Company; licensed by New York World's Fair.)

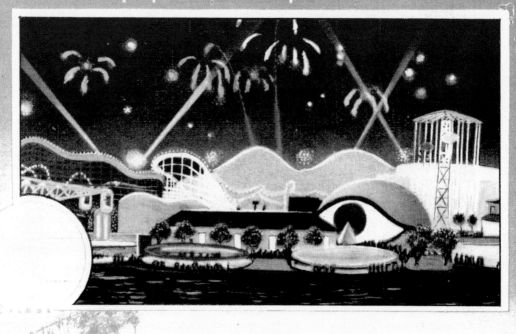

Greetings from New York World's Fair

156:-AMUSEMENT AREA AT NIGHT

THE AMUSEMENT ZONE AT NIGHT. Among the most memorable attractions of 1940s Great White Way were the rides. For a quarter or two, fairgoers could enjoy the Aerial Joyride, the Cyclone Coaster, the Bobsled, Frank Buck's Jungleland, Morris Gest's Midget Town, the Sky Ride, and the Whip. Clubs and revues offered toe-tapping fun, such as the delightfully open-minded Dancing Campus where, according to the 1940 *Guide Book*: "There is a place in the spotlight for all dance devotees whether your dish is the rhumba, conga, jitterbug capers or some yet unnamed step." (Image by Miller Art Company; licensed by New York World's Fair.)

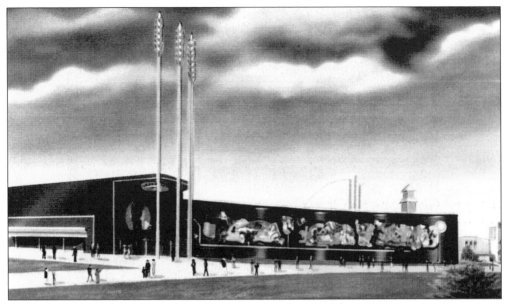

THE FOOD BUILDING SOUTH (NO. 3). Located at the junction of Rainbow Avenue and the Avenue of Pioneers, this building featured the Food Zone's focal exhibit: a demonstration of the changes in food production since 1789, with special emphasis on how modern dietary techniques had enhanced life and begun to eradicate preventable diseases such as night blindness due to Vitamin A deficiency. (Image created for Exposition Souvenir Corporation by Grinnell Litho Company; licensed by New York World's Fair.)

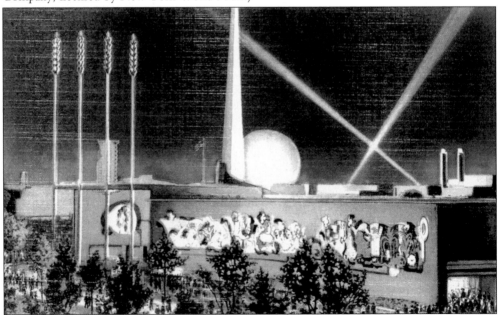

THE FOOD BUILDING SOUTH AT NIGHT. Witold Gordon's mural on the building's facade offered a 6,000-square-foot depiction of common foods. After the 1940s elimination of fair zones, Russel Wright's surreal focal exhibit was allowed to remain, but the building was turned over to one of its exhibitors, Coca-Cola, and its bottling plant. (Image by Manhattan Post Card Publishing; licensed by New York World's Fair.)

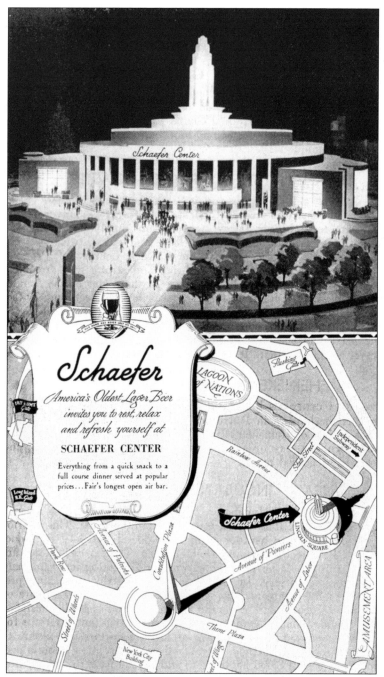

A Schaefer Center Advertisement. This advertisement from the 1939 *Guide Book* invites fairgoers to partake of a sudsy cold one at its 120-foot bar. To educate and uplift its visitors, the Schaefer Center presented a mural on the interior curve of the building that depicted the contributions of beer to developing civilizations across the centuries, from the days of the Phoenicians to modern times. As the first season gave way to the second one, the center also delighted visitors with its concrete fronting on which famous fair attendees left their handprints, footprints, and autographs. (Author's collection.)

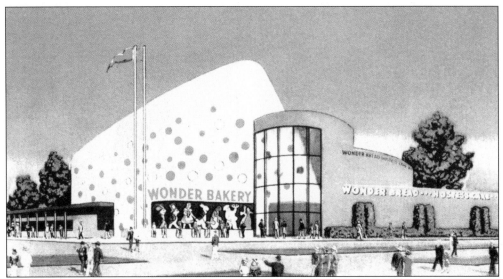

THE CONTINENTAL BAKING BUILDING. Located on the Avenue of Pioneers behind the Food Building focal exhibit, the Continental Baking Building presented a whimsical facsimile of a Wonder Bread wrapper, complete with blue, yellow, and red dots. It was the work of architects Skidmore & Owings. Along with freshly made sandwiches, visitors enjoyed samples of Hostess cupcakes. Behind the building lay the first wheat field planted in New York City in over 60 years. (Image by Continental Baking Company.)

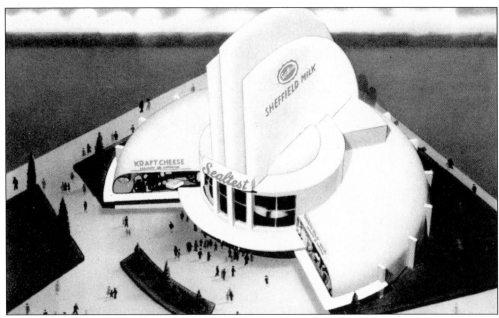

THE SEALTEST BUILDING. Emphasizing the 1930s-era concern for sanitation and public health, the Sealtest exhibit demonstrated the technologies of pasteurization and mechanized bottling processes. Preaching the virtues of research and quality control in the production of milk products might have stretched the attention spans of visitors, but Sealtest planners were smart enough to include a milk bar (a modernistic one, of course) that offered free samples. (Image created for Exposition Souvenir Corporation by Grinnell Litho Company; licensed by New York World's Fair.)

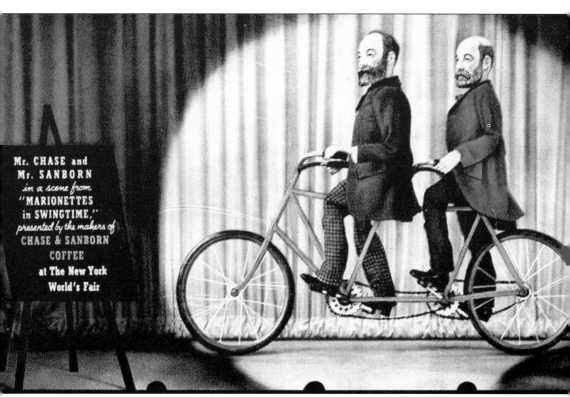

In the image: a sign reads:

Mr. CHASE and
Mr. SANBORN
in a scene from
"MARIONETTES
in SWINGTIME,"
presented by the makers of
CHASE & SANBORN
COFFEE
at The New York
World's Fair

THE CHASE & SANBORN *MARIONETTES IN SWINGTIME* SHOW. The Standard Brands Building, on Rainbow Avenue, was the work of architects Skidmore & Owings. The building was the venue for the Chase & Sanborn marionette show. The show offered a vaudeville-type attraction in which the marionettes, created by Sue Hastings, mimicked the comedy stylings of Charlie McCarthy, Edgar Bergen, Rudy Vallee, and Don Ameche. In the same building, visitors could have a cup of coffee, learn how Fleischmann's yeast was made, and test the vitamin content of their diets on the Menu Meter. At this time, the appeal of vitamins demonstrated an increasingly scientific motif in the production and advertisement of food. (Author's collection).

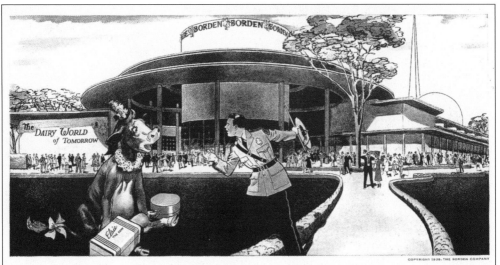

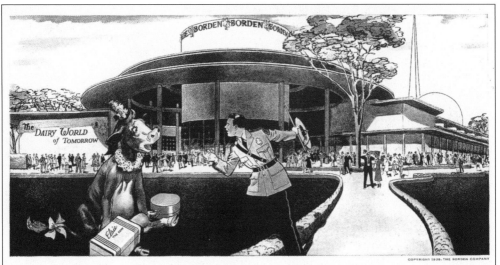

"—But you promised me a *Meadow!*"

ELSIE LOOKED DISAPPOINTED, dazzled, and curious, all at the same time—a rather difficult feat for a cow.

"It *is* a meadow, Elsie," insisted the World's Fair Man. "It's *Flushing Meadow*—the most wonderful meadow you'll ever see. All those bright buildings and wide avenues and gay flags have been put there for the *New York World's Fair*."

Elsie still hesitated. "Maybe it's just a bit too grand for me," she said. "Maybe I'll feel out of place."

"Nonsense," chuckled the Man. "You're going to have the time of your life here, living in 'The Dairy World of Tomorrow.' Why, you'll be in a lovely, air-conditioned Borden barn—you'll still eat the finest food—and you'll be milked on a merry-go-round . . ."

"What *fun!*" mooed Elsie, brightening. "But why bring me way out *here* . . . ?"

"So that millions of people can actually *see* how you live," the Man explained. "We want everyone to see the kind of care and skill and science that make milk so good it can be *Borden's Milk*."

"*And Borden's Ice Cream*," added Elsie.

"Ice cream—what do you mean?" puzzled the Man.

"Why, *Borden's Ice Cream* is made from my cream and milk," explained Elsie. "And because Borden sees to it that my cream and milk are always rich and good

as can be, Borden's Ice Cream naturally turns out to be rich and good, too.

"That also explains," she went on, "why *Borden's Eagle Brand Sweetened Condensed Milk* can be counted on to bring special goodness to *magic cooking*—the marvelous, new kind of kitchen-craft that makes tempting cookies, candies, and cakes in almost no time."

"Say," said the Man, "your milk does get around!"

"More than you think," agreed Elsie. "As *Borden's Evaporated Milk*, it contributes a particularly fresh, natural flavor to cream soups, mashed potatoes, and

many other good things to eat—because it's such very good *milk in the first place*."

"You've got quite a bit to do with the whole dinner

menu, then," the World's Fair Man said admiringly.

"Right down to the *cheese*," said Elsie. "My delicious milk also goes to make *Borden's Chateau* and all the other tempting members of *Borden's Family of Fine Cheese Foods*. It's even playing a very special role in Hollywood these days, besides."

"*Hollywood!*" exclaimed the Man.

"Yes, indeed," smiled Elsie. "My milk helps to make

Borden's Chocolate Malted Milk so good, refreshing, and satisfying that Hollywood stars pick it as the mainstay of light luncheons think about every dairy figures."

"Elsie," said the World's Fair Man, "I'll bet you turn out to be a real star here yourself!"

"I hope so," said Elsie, "for, I'd like to send our 'Dairy World of Tomorrow' audience home remembering this mighty important truth about every dairy product . . . *if it's Borden's it's GOT to be good!*"

More than 100,000 dairy farms furnish milk for Borden . . . more than 27,500 Borden employees work in behalf of 47,000 owner-stockholders, to provide the best of dairy products, to guard the goodness of all Borden foods, and to bring them to your home.

—if it's *Borden's* it's *got* to be good

"BUT YOU PROMISED ME A *MEADOW!*" This advertisement helped popularize Borden's spokes-bovine, Elsie, and explained her confusion about the Borden's exhibit: "Elsie looked disappointed, dazzled, and curious, all at the same time—a rather difficult feat for a cow." Fortunately, her tour guide explained that she *was* in a meadow, Flushing Meadows. "You're going to have the time of your life here, living in 'The Dairy World of Tomorrow.'" (Elsie trademark is owned by BDS Two Inc. and is used with permission.)

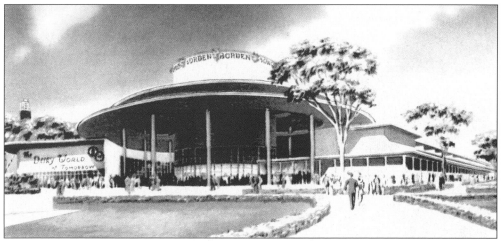

THE BORDEN COMPANY EXHIBIT. What else would a world's fair filled with futuristic highways and suburban utopias need? Rotating cows, of course. The Borden exhibit demonstrated modern practices of milk production aided by between 120 and 150 bovines, five of which revolved twice a day on an automatic milking machine called a rotolactor. This exhibit also helped create an advertising icon: Elsie the cow. (Created for Exposition Souvenir Corporation by Grinnell Litho Company; licensed by New York World's Fair; Elsie trademark is owned by BDS Two Inc. and is used with permission.)

THE 1939 *GUIDE BOOK* ADVERTISEMENT FOR THE BORDEN EXHIBIT. This advertisement from page 106 of the 1939 *Guide Book* helped inspire America's love of Elsie the cow. Initially, the bovine symbol stood for all the cows at the Borden exhibit. Soon, however, excited visitors began to ask, "Where's Elsie?" (Elsie trademark is owned by BDS Two Inc. and is used with permission.)

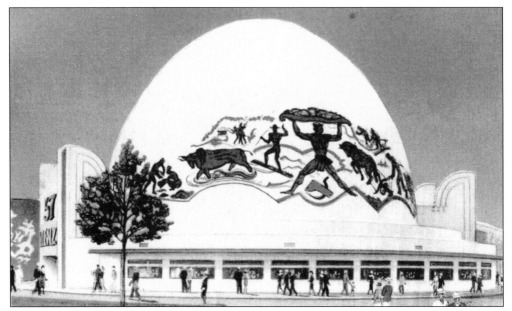

THE HEINZ DOME. After Grover Whalen rejected the company's plans for a giant pickle, Heinz settled on another building (most likely the original foods exhibit, although some historians note that building's potential use as a fisheries exhibit). Dominated by the murals of Domenico Mortellito, the Heinz exhibit wowed visitors with towering tomato vines, an animated Tomato Man, and Raymond Barger's *Goddess of Perfection* sculpture. The architects were Leonard M. Schultze and Archibald Brown. (Image by Manhattan Post Card Publishing; licensed by New York World's Fair.)

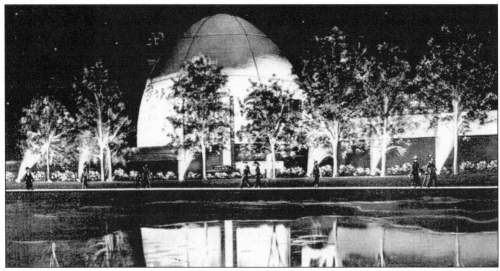

THE HEINZ DOME AT NIGHT. Of course, a major reason for stopping by the Heinz Dome (waggishly called the domo-cile) was to get free samples drawn from the company's famed 57 varieties. Visitors generally left the building with a tiny plastic Heinz pickle, a trinket that the company had begun distributing at the 1893 Columbian Exposition in Chicago. (Image by Interborough News Company; licensed by New York World's Fair; courtesy Lake County, Illinois, Discovery Museum, Curt Teich Postcard Archives and Richard Musante.)

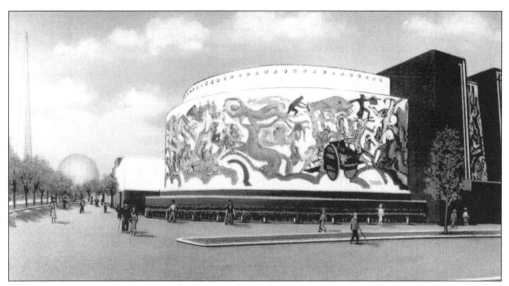

THE FOOD BUILDING NORTH (NO. 2). This building became the central food exhibit by the fair's second season. In both years, visitors encountered a somewhat random assortment of manufacturers ranging from Canada Dry to Wagner Baking. Pierre Bourdelle created the building's mural, a depiction of harvest. (Image by Frank E. Cooper; licensed by New York World's Fair; courtesy Lake County, Illinois, Discovery Museum, Curt Teich Postcard Archives.)

THE BEECH-NUT BUILDING. The Beech-Nut Building, designed and built by Magill Smith, stood on Rainbow Avenue across from the Brazilian Pavilion. Aided by a bevy of costumed "sampling girls," the exhibit featured the company's coffee, baby food, and gum-manufacturing processes with the aid of murals and dioramas. The Beech-Nut Building also attracted youngsters with its Biggest Little Show on Earth, a miniature circus featuring some 500 performers, including acrobats, clowns, and plenty of animals. (Author's collection.)

131:—AIRPLANE VIEW OF THE TRIBOROUGH
AND HELL GATE BRIDGES.

LEAVING THE WORLD OF TOMORROW. The Pennsylvania Railroad completed the Hell Gate Bridge in 1916 to connect New York and Boston. At one time it boasted the largest steel arch span in existence. The parallel two-and-a-half-mile suspension Triborough Bridge opened 20 years later to connect the Bronx, Queens, and Manhattan boroughs. An essay published by the Greater Astoria Historical Society notes that while Robert Moses received recognition as being the father of the Triborough Bridge, some historians credit George A. Haupt for his 1909 sketch that envisioned the bridge. A harrumphing Haupt explained, "Only the big fellows get the glory. The little fellow is never mentioned." (Image by Miller Art Company; licensed by New York World's Fair.)

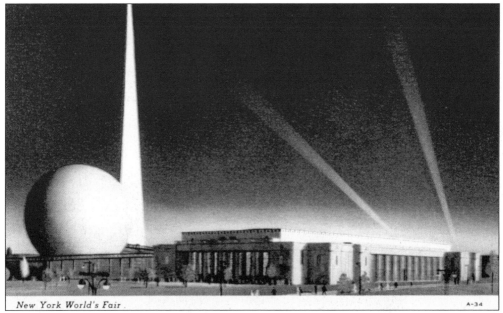

THE NEW YORK CITY BUILDING. In his short story "The Gernsback Continuum," William Gibson describes "semiotic ghosts" as pieces of the past that split off from their timelines to mix with ours. The New York City Building is one such semiotic ghost, a sign that the fair lives on as more than a trick of the memory. Built by architect Aymar Embury II as one of the fair's only permanent structures, the New York City Building highlighted the achievements of local government. Today, the building hosts the Queens Museum of Art and its impressive collection of world's fair artifacts and stunning panorama of New York City's boroughs. (Created for Exposition Souvenir Corporation by Grinnell Litho Company; licensed by New York World's Fair.)

FASTER AND FASTER. Advertisements such as this one from the International Nickel Company depict the 1930s' near obsession with the future as a site of nearly limitless possibilities. The text asks, "Can we still go forward? Will today's speed records be tomorrow's *average* speeds? Will buildings soar still higher above our city streets? Will even mightier liners sail the seas? Almost unbelievable to think that today's magnificent achievements may be surpassed . . . soon!" The world evoked by this advertisement may be strange to us, but stranger still is the fact that so many of the promises made at the fair came true: suburban living, multilane highways, and rockets to the moon and beyond. We live in the world imagined by the planners and designers of that great fair—and we live with consequences they could never imagine. (Author's collection.)

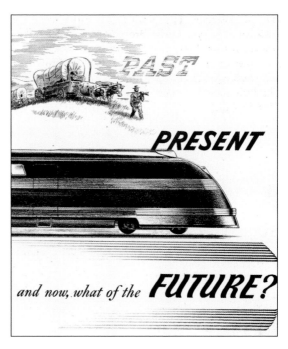

Index